IMAGES
of America
EARLY MASSILLON
AND LOST KENDAL

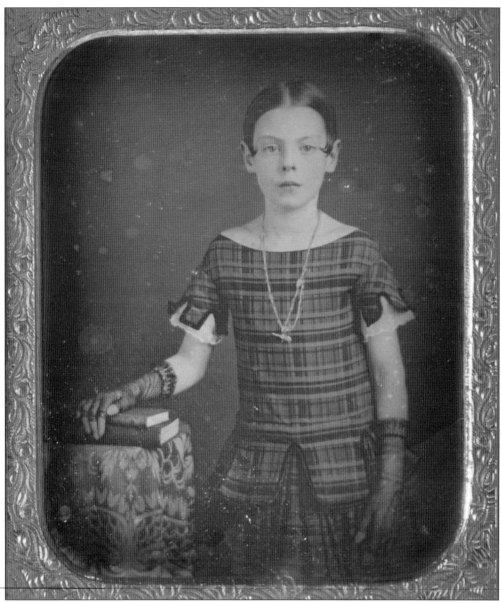

UNIDENTIFIED GIRL FROM THE NEALL FAMILY, C. 1850. Children in the early 1800s were dressed and treated as little adults. Photographing children was difficult, as necessarily long exposure times made any movement blurry. Dress for women at the time was conservative, but children's garments were less restrictive, allowing them to easily move and play. This girl seems too young to be dressed in evening wear with gloves, suggesting she may have selected her own outfit for the portrait. (Collection Massillon Museum, gift of Mrs. Mabel Reed, BC 1631.1b.)

ON THE COVER: Pictured around 1860 is the business block on the northeast corner of Main and Erie Streets. After an 1851 fire destroyed several blocks of downtown Massillon, this block was erected to accommodate a variety of businesses. Pictured are McLain and Dangler Company Dry Goods, Edward Kachler Books and Drugs, S.A. Conrad Hardware, Ricks and Brothers Dry Goods, and Merwin Sign Painting. (Collection Massillon Museum, gift of Mrs. Harry Conrad, 56.24.)

IMAGES of America
EARLY MASSILLON AND LOST KENDAL

Mandy Altimus Pond
Foreword by Margy Vogt

ARCADIA
PUBLISHING

Copyright © 2017 by Massillon Museum
ISBN 978-1-4671-2603-8

Published by Arcadia Publishing
Charleston, South Carolina

Printed in the United States of America

Library of Congress Control Number: 2016958780

For all general information, please contact Arcadia Publishing:
Telephone 843-853-2070
Fax 843-853-0044
E-mail sales@arcadiapublishing.com
For customer service and orders:
Toll-Free 1-888-313-2665

Visit us on the Internet at www.arcadiapublishing.com

In memory of John Sparks (1926–2017)

*John was a Massillon historian, a veteran of
World War II and the Korean War, a longtime volunteer
at the Massillon Museum, and a wonderful friend. Thank
you for the history and wisdom, my dear friend.*

CONTENTS

Foreword		6
Acknowledgments		7
Introduction		8
1.	The Rotches and Kendal	11
2.	The Underground Railroad	29
3.	The Duncans Establish Massillon	39
4.	Waterways and the Railroad	47
5.	Early Massillon Businesses	61
6.	Washington's Birthday Flood of 1848	81
7.	Early Education	93
8.	Religion	101
9.	Life in Massillon	107
Bibliography		127

Foreword

While historians have long revered the wealth of photographs and documents preserved by the Massillon Museum, the institution's archivist, Mandy Altimus Pond, has multiplied that treasure by poring through every scrapbook in the collection to unearth images of founders and leaders. She persevered through journals, ledgers, letters, legal documents, and personal papers, deciphering daunting 19th-century script to discover details disregarded as Massillon moved forward.

Although many Massillonians feel a pride in their past, the town's earliest history, as most know it, is like a winter tree—the Underground Railroad branch, the canal branch, the steam engine branch. This book puts leaves on the tree—an image of early business leader Charles K. Skinner; photographs of homes where fugitive slaves hid; the story of favorite son Horatio Watson as he trudged through the Mexican jungle seeking California gold. Readers will see rare interiors of homes and shops and unpublished street scenes.

The late-19th- and early-20th-century history of Massillon is well documented. Photographers recorded its streets, businesses, and people, while history devotees penned narratives told by generations just ahead of them. The more challenging documentation of Kendal and pre-1860 Massillon remained loved but less studied among the archives, until Altimus Pond embarked on her quest.

The author's passion for local history and her persistence have led to enlightening discoveries within the archives of the Massillon Museum, Spring Hill Historic Home, and Massillon Public Library. The importance of her mission and her enthusiasm have energized fellow historians, research professionals, and interns to help.

With a skilled photographic eye and a keen sense of what should be preserved for future historians, Altimus Pond can frequently be found recording the community today. She is rarely without a camera bag on her shoulder and a notebook at the ready. Her community involvement encompasses both her historic perspective and her aesthetic vision.

As the author of three Massillon history books, I am grateful that Altimus Pond has addressed longstanding questions and located invaluable documentation and visual materials. As a former Massillon Museum staffer who worked closely with the collections, I'm thrilled for previously unpublished information and images to be shared. And as a friend, colleague, and mentor, I am looking forward to *Early Massillon and Lost Kendal*.

—Margy Vogt

Acknowledgments

I owe much to my father, Rick Altimus; my Kent State Stark advisor and history professor, Dr. Leslie Heaphy; Kent State Stark history professor Dr. Thomas Sosnowski; and middle school history teachers Carole Mormon and Bill Paulus for inspiring my love of history.

For their tireless research assistance and scanning, I am grateful for Kelly Eggleston Licata, Megan Smeznik, Ben Ankrum, Jamie Woodburn, Michelle Persons, Meghan Reed, Laura Talarcek, Tara Freday, Erica Wise, and John Sparks. I wish to thank my mother, Deb Altimus, for using her genealogical wizardry and skills with photographic facial comparisons to help identify many of the people in this book. Thanks to Lois McHugh for scanning most of the images included in this book, and to Mark Pitocco for helping me photograph everything from small photographic negatives to large paintings and posters behind troublesome reflective glass.

I owe a great debt to the generations of historians before me: Robert Folger, Frank Harrison, David Palmquist, Albert Hise, Mary Merwin, Margaret Arline Webb (MAW) Pratt, Irene McLain Wales, Margy Vogt, and Andy Preston.

I must acknowledge published authors and historians Robert Folger, William Henry Perrin, Henry Howe, John Lehman, E.T. Heald, H.T.O. Blue, Mrs. Barton (Georgia) Smith, Ethel Conrad, Bessie V.R. Skinner, Mary Jane Richeimer, Ruth Kane, Barbara K. Wittman (Massillon Public Library), Terry Woods, and Margy Vogt, from whom I sought direction and evidence in support of my research. For their more recent research, thanks, Beth Odell and Sammy Kay Smith (Spring Hill Historic Home). Thank you to proofreaders Rick Artzner, Alexandra Nicholis Coon, Margy Vogt, Barbara K. Wittman, and Sherie Brown (Massillon Public Library).

I extend thanks to the Massillon Museum staff and Board of Directors for supporting this project, and Executive Director Alexandra Nicholis Coon for being a mentor and friend for more than a decade and for being supportive of and assisting in this endeavor.

I wish to thank my parents, Rick and Deb Altimus, for participating in and encouraging me in all of my projects, endeavors, and wild adventures. I offer my humble appreciation to my best friend and husband-to-be, Bryan Stahl, for his endless love, support, and encouragement.

The images in this volume appear, unless otherwise noted, courtesy of the Massillon Museum (MM); Spring Hill Historic Home (SHHH); Massillon Public Library (MPL); and the Abel Fletcher Collection, Seaver Center for Western History Research, Los Angeles County Museum of Natural History (Seaver Center).

Introduction

Assembling this book has been an exciting journey through rarely accessed archival materials in the collections of the Massillon Museum, Spring Hill Historic Home, and Massillon Public Library.

At the beginning of the research process, I worried about not finding enough photographic content, since 27 years of early Kendal and Massillon history had passed before the invention of photography in 1839. When my search through the Massillon Museum's archive of more than 60,000 photographs and Spring Hill's hundreds of photographs was completed, more than 800 potential images had surfaced to illustrate this book's timespan, 1812 to 1860. The challenge was to carefully select those 200 images which best illustrate the book topic. Many interesting subjects were omitted due to space constraints. I let the images be my guide and make no claim to a comprehensive history of this era. For a more complete history of Kendal and Massillon, please refer to the bibliography at the back of this book.

In some instances, buildings and events could not be photographed, and I chose comparable images, as noted in the text. For example, neither the 1848 flood nor its damage were captured; therefore, photographs of the more recent Massillon 1913 flood damage are used for illustration. Street names referred to in this book are those of the time period. Please reference the map on page 10 for current street names.

As archivist for the Massillon Museum, I have had the privilege of spending more than a decade caring for these photographs, overseeing their digitization, reproducing them for researchers, and sharing them online. The photographs in this book shed light on little-known carriage factories, dry goods stores, woolen mills and gristmills, hotels, people, events, and homes on the Underground Railroad. Combining research previously conducted by various Massillon historians, I was able to identify possible photographs of original Thomas Rotch structures in Kendal and businesses in Massillon, which were believed to have been lost. Many of the images seen in this book have not previously been published or shared.

Family photograph albums, preserved in the Museum's collection, provided a look at a family, their distant relatives, friends, and business associates. Several of the images in this book, which are known to be the only extant photographs, came from the carefully preserved pages of those albums.

I used primary sources when available, including never-before-published firsthand accounts of the 1848 Washington's Birthday Flood. Kent Jarvis letters written to his brother were donated in the 1970s, long after most histories of the flood had been published. Several passages of his first-person account are included in this book. Passages of Arvine Chafee Wales's 1848 diary have been transcribed and his stories incorporated throughout the book. Mary Jarvis Fay's 1896 memoir, preserved in the Massillon Museum archives, details life in 1850s Massillon and the story of the Jarvis family.

Personal, business, and school papers in the Massillon Museum archives provided primary source insight into the lives of our citizens. These include Charles K. Skinner (papers from 1810 to 1860), Kent Jarvis (papers from 1820 to 1870), James Duncan, and Robert Folger. The Museum

preserves Barack Michener's handmade 1810s schoolbooks, a transcribed 1820 Kendal census, and an interview with Sam Mauger conducted by Frank Harrison in 1941. Museum clipping files provided secondary resources, containing newspaper articles and Museum staff and volunteer research. Early Massillon Museum historian Frank Harrison created a detailed tax and property map for early Kendal, just before his untimely death in World War II. Massillon city directories (1853, 1859, 1876–1980s) provided lists of citizens and businesses alphabetically and by category of business. These are available in-person at the Massillon Museum and the Massillon Public Library, as searchable digital scans online, and as a searchable business and industry database across many decades.

The Massillon Public Library preserves the Rotch-Wales papers (1758–1897), containing approximately 15,000 documents to and from Thomas and Charity Rotch, Arvine Wales I, Arvine Chaffee Wales, and others. This collection includes 1840s–1850s letters from Horatio Watson to Arvine Chaffee Wales, detailing political affairs in Massillon and his journey west to the Gold Rush; accounts of Indian affairs and settlers' fear of attack during the War of 1812; assisting fugitive slaves as part of the Underground Railroad; an 1820 letter from George Duncan, a fugitive slave who stayed at Spring Hill, asking Thomas Rotch to help retrieve his wife, Edy; Quaker religious matters; and so much more.

Thomas and Charity Rotch were dedicated to the enrichment and success of their new community. Thomas Rotch served as ambassador to local Indian tribes to ensure their interests in US negotiations. Both Thomas and Charity served in the Quaker community, preaching and participating in the Yearly Meeting. Charity Rotch established the first vocational school in the state of Ohio, helping underprivileged children access education from 1829 to 1910. The funds from her school carry on today as a foundation that provides scholarships in Western Stark County. I am privileged to serve as the foundation's secretary and treasurer. The Massillon Public Library, Spring Hill Historic Home, and Massillon Museum preserve original documents from the Charity School of Kendal, and staff are working to create a full student database.

The story of Kendal and Massillon intertwines with national and international history. This book shines light on people like Joseph Davenport, inventor of train cowcatchers and railroad car center aisles, and founder of the Massillon Bridge Company; along with early examples of images by photographic pioneer Abel Fletcher, who was among the first American practitioners of the paper negative in his South Erie Street studio. Massillon manufacturers sold their goods throughout the country. Among the most successful was Russell & Company, known for making farm equipment that sold across the world, but also specializing in burial cases and furnished hearses. Businesses surrounded the Ohio and Erie Canal, providing services and shipping across the state. Coal mining in this area was thought to have started in the 1870s, but during research in the archives, it was discovered that the first mine was at Bridgeport, which sent its first load of coal to Cleveland in 1828. Commercial mining in the Massillon area began in 1833. According to an interview with Sam Mauger, the first piece of coal mined in Massillon was burned at Robert Folger's Commercial Inn.

Several early Massillon newspapers are preserved in the Museum archives from the 1830s to the 1880s. A great historical resource is the *Massillon Weekly American* newspaper, published April 16, 1884. Reporters visited "aged" citizens to gather stories of businesses and families. I believe the newspaper editors expressed the sentiments about the town's early history the best:

> In reviewing the hardships and privations that these early pioneers must have endured, to withstand the savage beasts and savage men, and lay the foundations . . . we can only take the hand of these aged veterans and gaze upon the work they have accomplished with the most profound respect.

I am humbled to follow in the footsteps of so many historians and authors before me. I hope you enjoy reading about early Massillon and the often forgotten village of Kendal, and seeing newly illuminated images from the archives.

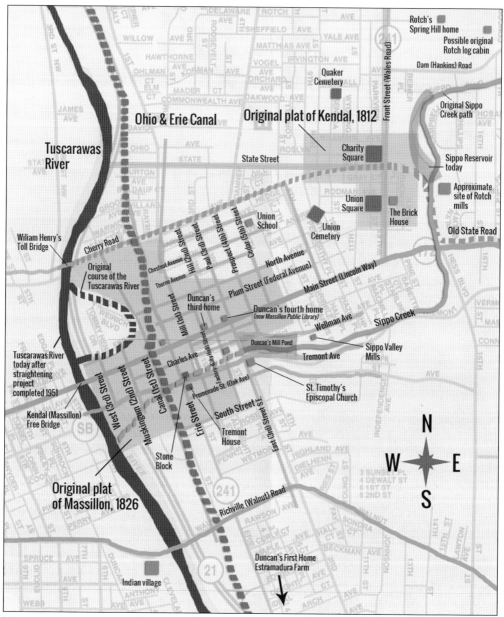

MAP OF MASSILLON AND KENDAL. This map shows the original street names along with their current names, the original and current paths of the Tuscarawas River and Sippo Creek, and the former location of the Ohio and Erie Canal. (Courtesy of Mandy Altimus Pond.)

One
THE ROTCHES AND KENDAL

Kendal, Ohio, was founded by Thomas and Charity Rotch, prominent Quakers and members of powerful New England whaling families. They moved from Hartford, Connecticut, to Northeast Ohio in 1811 to escape the harsh North Atlantic coastal climate. The Rotches chose Ohio because their Quaker convictions prevented them from living any farther south where slavery was permitted. Thomas Rotch recorded the plat of Kendal on April 20, 1812. Rotch attracted many of his seafaring and Quaker friends from Nantucket and New Bedford, Massachusetts, and Hartford, Connecticut, to build homes in Kendal.

Travel was treacherous on uneven roads. A trip from Kendal to Canton took three and a half hours. Arvine Wales set traps for wolves, for which the county government offered bounties. Other wild animals, such as panthers and bears, also posed a threat. The War of 1812 slowed Kendal's growth due to uncertainties of the frontier and the high price of building materials. Gen. William Henry Harrison's United States troops camped here, while British forces encouraged American Indians to raid white settlements.

After Thomas and Charity's deaths in 1823 and 1824, respectively, Kendal became an Owenite utopian socialistic community, visited and praised by Robert Owen. The Friendly Association for Mutual Interests, also called the Kendal Community, purchased more than 2,000 acres of Thomas Rotch's estate. Unrelated to any religious affiliation, the pact was based on the concept of community, trust, and sharing. The 29 families signed a bond to the community. Wages set by the community included women's wages of 75¢ per week for housework. Each family received a house, firewood, and stake in the land for a community garden. At year's end, profits were divided equally. This was considered the most successful and longest enduring Owenite community of its kind, mainly because of the members' familial connections, friendship, and trust. Soon after a group of 185 Owenites from New York State arrived in Kendal under the leadership of Samuel Underhill, the debt became too great. One by one, families left the community, cashing out their investments. Rotch heirs demanded foreclosure of the community's mortgages, and the experiment failed in 1829.

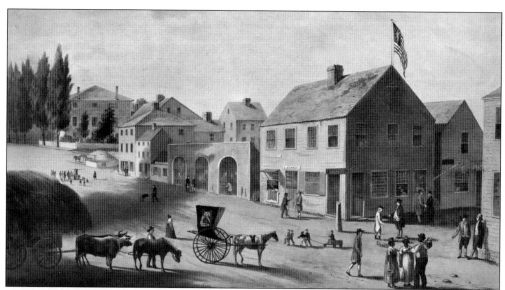

"New Bedford, Fifty Years Ago," 1858. This depiction of New Bedford, Massachusetts, in 1808 shows William Rotch Sr. and William Rotch Jr. seated in the carriage at the center of the print. Several Rotch homes are visible in the background, illuminating the Rotch family's prominence in the New Bedford community. (Lithograph by William Allen Wall, published by Charles Tabert and Company, Boston, MM, gift of Mrs. H.W. Wales, 66.76.)

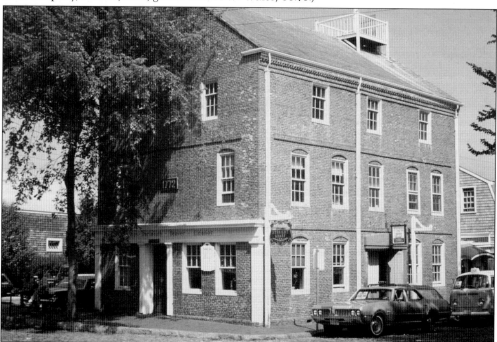

William Rotch's Counting House, Nantucket, Massachusetts, c. 1971. William Rotch, father of Kendal founder Thomas Rotch, owned the ships *Dartmouth* and *Beaver*, which were involved in the 1773 Boston Tea Party. The *Beaver* was the first whaling ship to round Cape Horn. He also owned the *Bedford*, which was the first vessel to fly the American flag in British waters after the Revolution, in 1785. (Photograph by David Palmquist, MM.)

Silhouette Likenesses of Thomas Rotch and Charity Rotch, c. 1970. No photographs of Thomas or Charity Rotch exist, as they died prior to the invention of photography. These are the closest extant likenesses of the Rotches, created from Rotch and Rodman family portraits at the Peale Museum in Baltimore, Maryland. Thomas Rotch contracted bilious fever while at the Quakers' Yearly Meeting in Mount Pleasant, Ohio, and died at the age of 56 in September 1823. Per Quaker custom, he is buried there. Charity, who had been stricken with spotted fever in 1808, continued to have relapses and health concerns for the rest of her life. Modern researchers believe she had high blood pressure and heart disease. She died of dropsy in August 1824. (SHHH.)

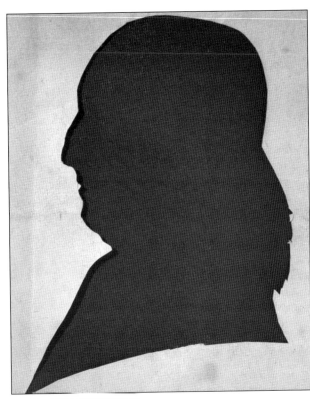

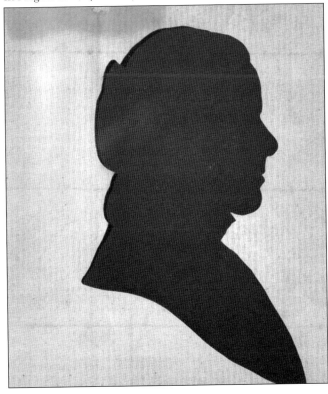

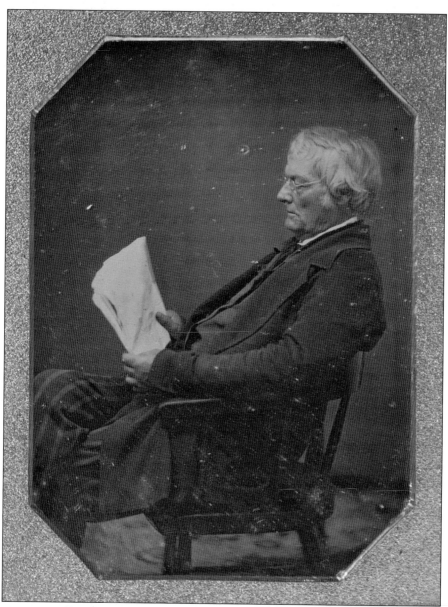

DAGUERREOTYPE PHOTOGRAPH OF ARVINE WALES, C. 1850. Arvine Wales was born in New Stanford, Vermont, in 1785, and moved to New Bedford, Massachusetts, to work for the Rotch family. In 1811, when Thomas and Charity Rotch began their trek to Ohio, Rotch paid $1,200 to Wales and eight men, who drove 408 sheep 600 miles from Hartford, Connecticut, to Kendal, Ohio, over the course of two months. The flock was valued at between $40,000 and $50,000. In Kendal, Arvine Wales was heavily involved with the community. He was president of the first public Union School board, presided over the Charity School of Kendal board, and served in the leadership of the Kendal Friendly Association for Mutual Interests. He was executor of Thomas and Charity Rotch's estates. Wales was married three times: to Mary Kimberly, Ann Foote Baldwin, and Nancy Shepherdson. Arvine and Ann Wales had one son, Arvine Chaffee Wales. Arvine Wales died in 1854. This is one of only two photographs of Arvine Wales known to exist. (SHHH, SH 2025.2.)

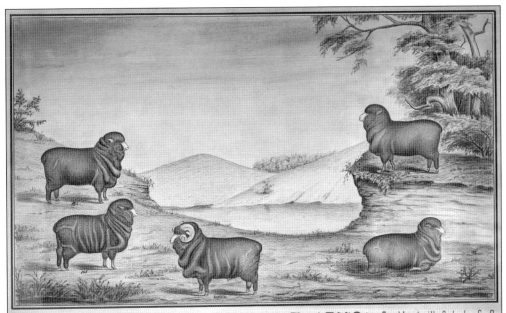

Group of pure bred American Merino Lambs, aged 9 Mos. Bred and owned by Samuel T. McGuire. Canal Lewisville Coshocton Co: O. This Herd is tracing to the Humphrey importation of 1802, through the herds of N. L. Archer, E. Hammond and Atwood.

PUREBRED AMERICAN MERINO LAMBS, 1880. Samuel T. McGuire held records that traced his Merino sheep to the Colonel Humphreys importation of original purebred Merino sheep in 1802, the same flock from which Thomas Rotch's Merino sheep originated. McGuire lived in Canal Lewisville, Coshocton County, Ohio, and his sheep were sketched from life for this image. (Pencil and ink on paper by C. Freigau, Dayton, Ohio, MM, gift of Albert Hise, 60.149.)

SHEPHERD'S BOOK OF SAMUEL BACHTEL, 1842. Farmer Samuel Bachtel of Jackson Township kept a log of every sheep in his flock and any he was hired to care for, shear, or breed. He affixed samples of that wool with wax on carefully catalogued pages. Bachtel kept a tally of sheep, sales records, and a description of each marking for separate flocks of several hundred buck, ewes, and babies. Entries include full-blooded Merino sheep from Adam Holderbaum and Charles Skinner. (SHHH.)

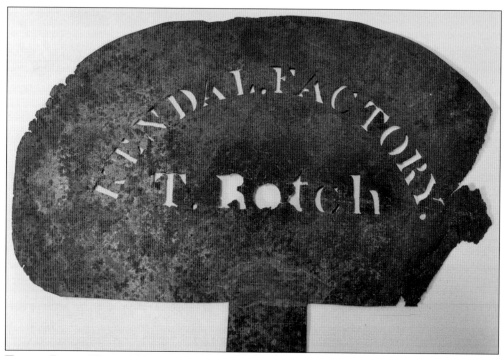

THOMAS ROTCH KENDAL WOOLEN FACTORY STENCIL, C. 1815. Thomas Rotch used this stencil to paint "Kendal Factory" on bolts of cloth from his woolen mill. He carefully recorded his sheep to identify their lambs and processed the fabric at his mill. Branding distinguished Rotch woolens from those of other nearby manufacturers and conveyed pride in his woolen mill. (SHHH.)

PRINT OF THOMAS ROTCH'S SEAL, C. 1820S. Rotch was one of only a few farmers in America in the early 1800s to own Merino sheep, whose wool was highly sought. Color options were blue, scarlet, lustre, and crimson. Wool carding options included sugar, tallow, beeswax, linen, fine tow D, clover seed, and leather uppers and sole. To keep the common sheep's wool separate from the fine Merino wool, separate machines were maintained. (MM, gift of Mrs. Horatio W. Wales, BC 2841.3.)

ROTCH CERTIFICATE FOR MERINO NUMBER 1, C. 1815. Col. David Humphreys, a Revolutionary War veteran, served as ambassador to Spain, where he obtained Merino sheep in 1802. A letter from John Street of Salem, Ohio, to Thomas Rotch in 1813 reads, "I have my own troubles with my sheep as there are so many runagate rams about (of the common kind) that it is with great difficulty I can keep them from my ewes as some of them know not what a fence is made for." (SHHH.)

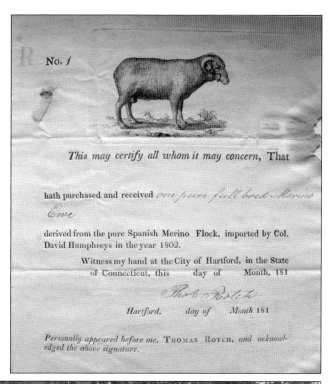

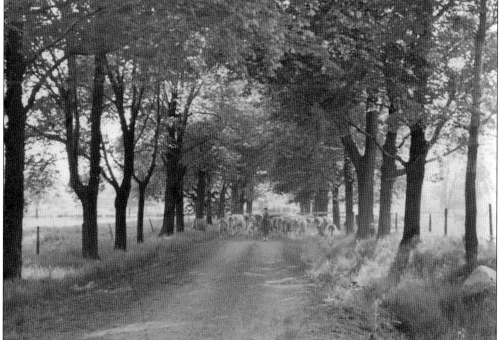

BOB HESS LEADING CATTLE UP SPRING HILL LANE, C. 1950. The responsibility for Rotch's sheep was divided among local farmers, and during harsh winters the sheep were sent further south to Steubenville, Ohio. The Spring Hill farm grew crops, maintained farm animals for many decades, and later established a dairy and orchard. (SHHH, SH 2358.)

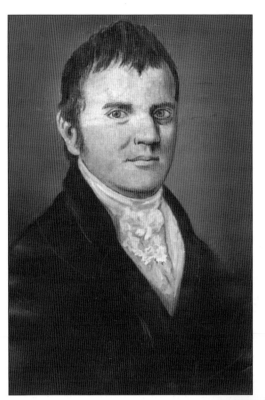

CAPT. MAYHEW FOLGER (1774–1828), c. 1810. Capt. Mayhew Folger circumnavigated the globe in the late 1700s and rediscovered Pitcairn Island in 1808. The inhabitants included the last surviving mutineer from the famous ship *Bounty*. Pitcairn residents and the Folger family continued correspondence into the 1890s. When he moved to Massillon, he served as the first canal toll collector and the first postmaster. (MM, gift of Margretta Bockius Wilson, BC 2363.3.)

MARY JOY FOLGER (1778–1858), 1855. Mary Joy undoubtedly spent time on the widow's walk of their home in Nantucket, awaiting the safe return of her husband, Mayhew, who ventured on many long and dangerous seal-hunting trips and was once kidnapped. Mary Joy Folger could no longer stand the strain of awaiting his safe return and encouraged Mayhew to move the family west away from the tempting salty air of the ocean. They moved west in 1810 to Chester County, Pennsylvania, and then to Kendal in 1813. (MM, BC 2363.5.)

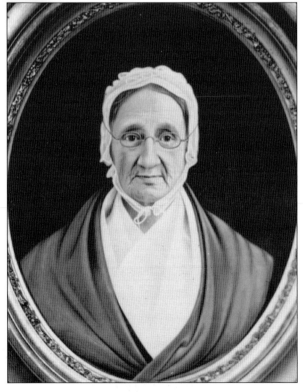

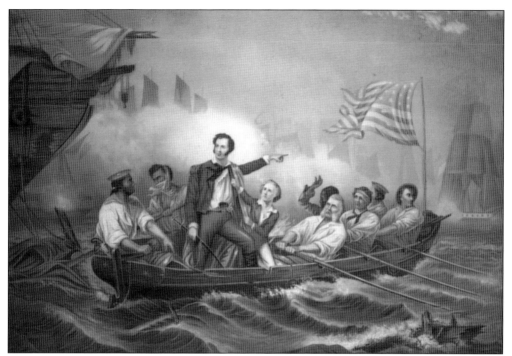

COMMODORE PERRY IN A ROWBOAT, WAR OF 1812. During the War of 1812, the British asked Indians to attack the Ohio settlers. Nantucket's whaling industry was stagnated by the sea warfare. Victories in the war were celebrated across the new nation. A new hero emerged after the Battle of Lake Erie: Commodore Perry, a relative of the Rotch family. Perry Township, where Kendal is located, was named for him when it was established in 1813. (MM, gift of Albert Hise, 68.70.13.)

KENDAL TAVERN, C. 1900. Often thought by contemporary Massillonians to be Mayhew Folger's Tavern, according to Frank Harrison's research, the property belonged to Edward Nelson. The tavern served travelers along the State Road, Ohio's main thoroughfare at the time. Historical references claim the tavern served 100 families per month. The water company's 1886 standpipe is seen farther east. (MM, BC 2307.3.2.)

Spring Hill Farm from Hankins Road, c. 1900. The small building at the far right of this photograph is believed to be Thomas Rotch's original log cabin, where he and his team lived while they prepared the town of Kendal for settlement. Most historians refer to his cabin being north of the village, but historian and author Ethel Conrad states, "They arrived in early December [1811], and hastily built a small cabin and a sheep cote on a hillside near one of the springs." If Conrad's description is correct, this may be the only known photograph of that original cabin. At center may be the spring house, a white building to the right of the main house on the highest point. The grounds of Spring Hill farm contained a horse barn, coach barn, cornshed, sheep barn, milk house, hog barn, wool house, icehouse, and tenant homes. Arvine Wales purchased the Spring Hill property after the Kendal Owenite experiment failed in 1829. It was inhabited by the Wales family for three generations until the 1970s. In 1972, Irene McLain Wales left the home and grounds to the Massillon Museum Foundation to be opened as a historic house museum. (SHHH.)

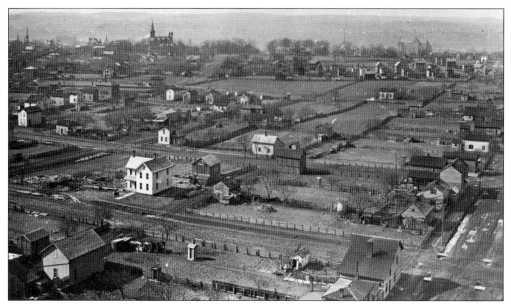

FORMER SOUTHWEST KENDAL AS SEEN FROM STANDPIPE, 1890. The north-south plat of Rotch's original survey of precisely measured lots can be seen in this aerial photograph. The tall spire toward the left of the photograph is North Street School, built in 1879. The building in the bottom right corner is probably Thomas Rotch's dry goods store. (Photograph by Albert Coleman. MM, gift of Karl Spuhler, 91.7.3109.)

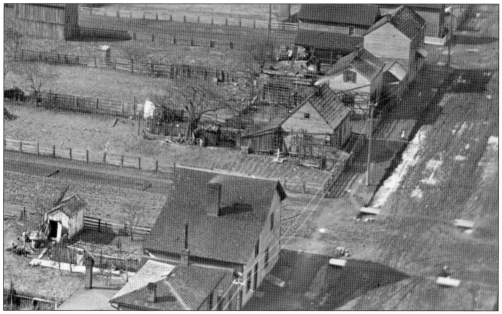

THOMAS ROTCH'S DRY GOODS STORE, DETAIL OF AERIAL VIEW, 1890. Rotch was appointed the first postmaster of Kendal by Gideon Granger in 1812. The post office was located in Rotch's store on the southeast corner of State Avenue Northeast and Second Street Northeast (Parkview). The post office moved to Massillon in 1828 and Mayhew Folger was appointed postmaster, using space in his Commercial Inn. The "L" house is at the top right of the photograph. (Photograph by Albert Coleman. MM, gift of Karl Spuhler estate, 91.7.3109.)

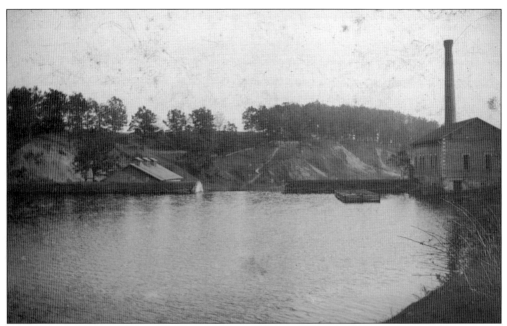

SIPPO RESERVOIR AND ROTCH'S MILL, C. 1886. The detail of this Sippo Reservoir photograph shows the roof of a building below the falls. According to old stories from residents and map descriptions, this is either Thomas Rotch's sawmill or woolen mill, making this the only extant photograph of that mill. (MM, gift of Florence Fielberth Snyder estate, 62.170.1.)

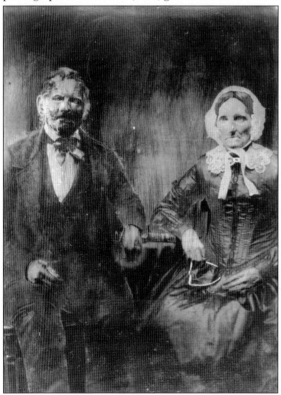

AMASA (1792–1873) AND SALLY (1794–1877) BAILEY, C. 1860. The Baileys lived in Cleveland for several years and founded the first side-saddle company in Cuyahoga County. Bailey Sr. fought in the War of 1812. In the early 1820s as the family traveled through this area, Amasa Bailey Jr. was born in the Brick House. The family decided to settle here. In his later years, Bailey Jr. would recall, "If it hadn't been for that house I probably would have been lost along the road somewhere." Bailey Sr. was secretary of the Kendal community. (MM, BC 2336.)

OLD MILL RACE ALONG SIPPO CREEK, C. 1885. This mill race is believed to have run along the Sippo Creek south of Main Street. The flowing water provided power to a mill in the first half of the 19th century. Based on the location, the mill was likely the site of the Massillon Iron Company. (Photograph by J.C. Haring, MM, BC 2313.14.3.)

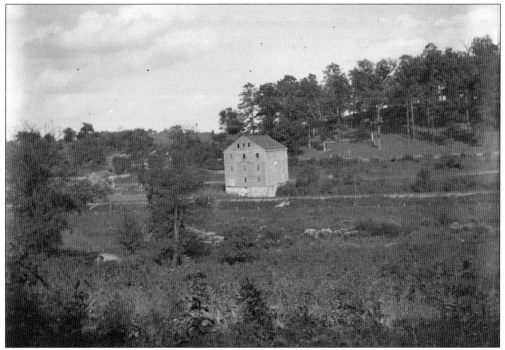

UNIDENTIFIED MILL, C. 1890. The terrain of this photograph and the one above indicate that this mill may have stood along the Sippo Creek using power from the mill race featured above. If this photograph was taken in the Sippo Valley, it likely pictures an early Kendal mill, and potentially one that belonged to Thomas Rotch or Mayhew Folger. (MM, museum purchase.)

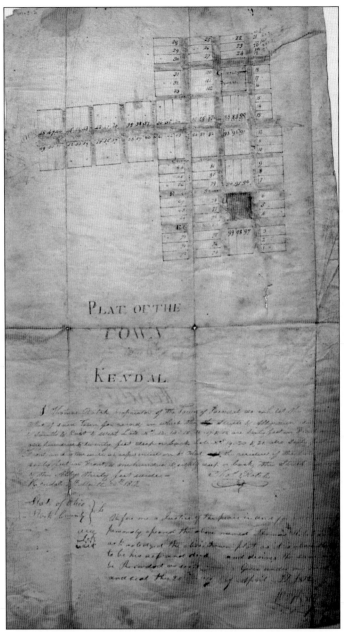

PLAT OF THE TOWN OF KENDAL, 1812. Thomas Rotch purchased 4,000 acres and created 102 lots. Kendal—named in honor of Kendall in Cambria, England, the heart of the British textile industry—was surveyed and laid out by Thomas Rotch. His streets and lots are arranged in a north-south orientation, unlike Massillon, whose lots are oriented based on the path of the Tuscarawas River. Rotch's survey tools are part of the Spring Hill Historic Home permanent collection. Thomas Rotch envisioned his town as the establishment of a new frontier with various industries relating to the raising of sheep, processing of fine wool, and selling of cloth. By 1817, there were four stores and 50 houses. Bradford Kellogg opened his brickyard in 1813. Within a few years, there was a sawmill, tannery, blacksmith, and wagon shop. When Rotch competed with William Henry's western settlement for postmaster, Kendal was awarded the post. (MPL.)

CHILDREN SEATED AT UNION SQUARE, C. 1900. Union Square was one of two village greens set aside in the Kendal plat along the main north–south road, Front Street, to create the atmosphere of a New England town. The two-story brick structure at the right, the home of Alexander Skinner, later served as a community center. James Duncan, founder of Massillon, made the Brick House his second home in the area, and the contracts for the Ohio and Erie Canal were signed here on January 18, 1826. This is the only known photograph of this 1816 home, demolished in 1911. The white frame, two-story house built by Charles Coffin in 1812 sat on lot 8. Rotch described it as "tolerably finished and occupied as a weaving house." Samuel Patton's community well sat on the southern edge of Union Square. The other green, Charity Square, was four blocks north of Union Square. The water company's 1886 standpipe, which provided residents with water, towers in the middle of this image. (Photograph by George McCall, MM, BC 2307.7.3)

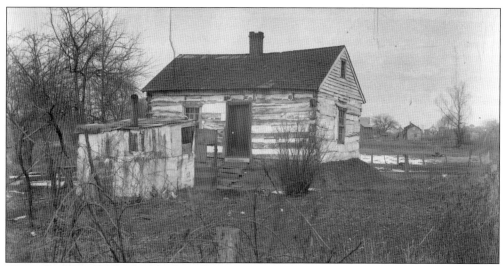

UNIDENTIFIED LOG CABIN NEAR MASSILLON, C. 1890. Log cabins dotted the landscape of Ohio's early settlement, but Thomas Rotch wanted to avoid this style of home in Kendal. Though Rotch's strict building requirements applied within the village limits, he himself built and lived in a log cabin outside the village while his Spring Hill home was being constructed. Rotch slept in a hammock hung from the rafters of the cabin he shared with his employees, among whom was Arvine Wales. (MM, gift of Dan Douglass, 90.25.307.)

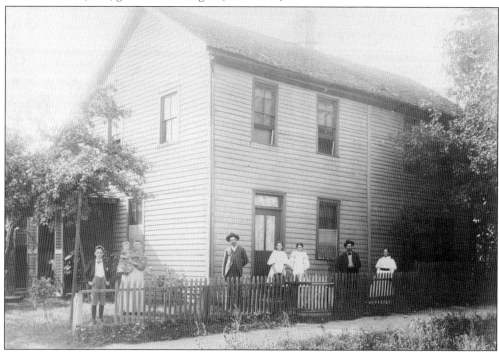

GREENWALT FAMILY, KENDAL, C. 1895. One of the architectural designs deemed acceptable for Kendal was the saltbox style, characterized by a long slanted roof. Built in 1837, this two-story framed duplex sat on the southeast corner of Second Street (Parkview) and State Street northeast, on lot 87. The home was razed in 1948. Pictured from left to right are Walter, sister Helen, their mother, Leonard, Amelia, Clara, Frank, and his mother Eliza. (MM, gift of Dale E. Young, 12.022.27.)

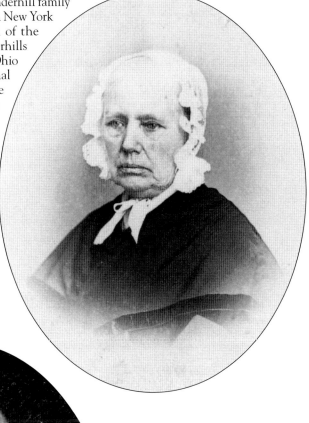

ANNIE UNDERHILL, C. 1860. The Underhill family was part of an Owenite community in New York that had failed. When they heard of the successes of Kendal, Ohio, the Underhills and several other families moved to Ohio in 1829, traveling west by the Erie Canal to Cleveland, and then south by the Ohio and Erie Canal for three days until arriving at their destination. Underhill was the first matron of the Charity School of Kendal in 1844 when the school building was constructed as a boardinghouse. (MM, gift of Warren Russell, BC 999.3.)

JEHIAL FOX, C. 1845. Jehial Fox served as president of the Kendal Community during the Owenite experiment. A carpenter, architect, and businessman, he is credited with building Spring Hill home in 1821, and the Arvine Wales barn in 1837. His business ledger is preserved in the Massillon Museum collection. (MM, BC 2365.1.)

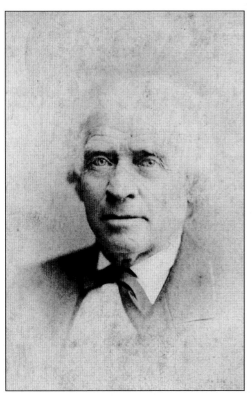

JAMES (1808–1896) AND ELIZA FOX (1814–1891) BAYLISS, C. 1875. James Bayliss was born in the home of William Shakespeare—in Stratford-on-Avon, England, on November 7, 1808. He came to America with his family in 1818 to Philadelphia, Pennsylvania. He began studying under the tailor John Tack in New York City and came to Ohio in 1827 by way of Cleveland to join the Kendal Community. He served on the board of Charity School of Kendal for four years. On January 1, 1831, he married Eliza Fox, daughter of Jehial Fox, the president of the Kendal Community. The couple had five children. In 1849, Bayliss traveled with several friends to California to try his luck in the Gold Rush, returning two years later with a decent quantity of gold. James purchased land in Tuscarawas Township in 1833 and set up a farm, lumberyard, and sawmill. He was an organizer and president of Massillon Coal and Iron Company, tailor (1836–1849), dry goods clerk (1852–1856), farmer, and wool buyer. (Photographs by J.C. Haring; both MM, BC 2339.1 and .2.)

Two

THE UNDERGROUND RAILROAD

Though slavery was the law of the land, Quakers did not believe in human bondage. Isaac Russel wrote from a southern state to Thomas Rotch in 1816, "I can have little satisfaction in remaining long in this state when abominable slavery is tolerated with all its concomitant evils, evils which I witness with disgust and dismay."

The Fugitive Slave Act of 1793 guaranteed that slaveholders could recover escaped slaves if pursued. Yet, if runaway slaves reached a free state, they were likely to be left alone, until the Fugitive Slave Act of 1850, which further enforced the recovery of runaways by compelling citizens of free states to return slaves to their masters, making it illegal to harbor slaves even in free states. This law presented a moral dilemma for dutiful citizens who wished to help runaways.

Charity Rotch wanted to help fugitive slaves, but the stressful situations exacerbated her illnesses. She wrote to her sister Anna Hazard, "poor things, they excited so much sympathy and so prey upon my feelings that I should be glad to have but little of their company." Through original Rotch letters, there are well-documented stories of the family helping fugitive slaves obtain food, clothing, and guides for their journeys. Thomas Rotch served on Yearly Meeting committees that improved slave conditions and worked toward their emancipation.

Many Kendalites and Massillonians were involved in the Underground Railroad. According to Dr. William Siebert's 1898 book *Mysteries of Ohio's Underground Railroad* and newspaper articles, those who assisted in ferrying runaway slaves included James Austin, James Bayliss, Isaac Bowman, Charles Coffin, Matthew and Samuel Macy, Isaac Robinson, Irvine and Richard Williams, Charles Grant (black conductor), William Moffit, Robert Folger, and Levi and Catherine Coffin. Levi Coffin later moved to Indiana and is credited with naming it the Underground Railroad in 1831.

Ohio freedom networks were established in the late 1810s. Several Quaker families from Ohio to Massachusetts visited friends in Wheeling, West Virginia, and helped fugitive slaves cross the Ohio River. They attempted to take them as far north as possible, from Kendal north to Hudson, Ohio, and typically to Canada. Since not every escape was documented, it is hard to say how many fugitives escaped. Some scholars say 40,000, while others say 100,000.

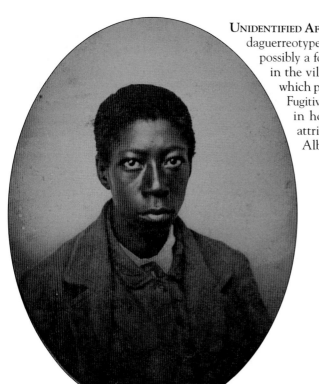

UNIDENTIFIED AFRICAN AMERICAN BOY, C. 1845. This daguerreotype depicts an unidentified young man, possibly a former slave who found a new home in the villages of Kendal or Massillon, Ohio, which provided opportunities for all people. Fugitive slaves found employment in houses, in hotels, and on farms. (Photograph attributed to Abel Fletcher, MM, gift of Albert Hise, BC 1624.)

GEORGE HARSH, C. 1870. According to Harold Boerner's map of historic locations, the home of George Harsh on Prospect Street Northeast was a station on the Underground Railroad. Harsh gave a substantial $10,000 bequest to help establish the Massillon Public Library in 1899. (MM, gift of Mrs. Myrtle Kisner, BC 2371.1.)

SPRING HILL FARM, 1900. A notorious slave catcher, known only as DeCamp, helped slaves to escape, only to track and return them to their masters for a reward. He tracked a fugitive slave woman and her children to Spring Hill farm and demanded their surrender. Thomas Rotch told him to leave, but DeCamp reminded him of the Fugitive Slave Act. The farmhands surrounded DeCamp with weapons, such as pitchforks, and he was encouraged to leave the grounds. (Photograph by George McCall, MM, gift of the Karl Spuhler Estate, 91.7.1948.)

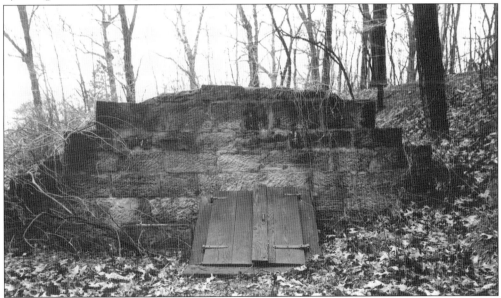

REMAINS OF SPRING HILL FARM SPRINGHOUSE, 1970. The springhouse provided a hiding place for fugitive slaves until the main home was built. Fugitive slaves hid in the upper story of the springhouse until a trusted conductor was found. Any more than a few days would bring attention, putting the home owner and fugitives in danger. When it was safe, fugitives traveled to the next station in northern Ohio near Stow, Hudson, or Painesville. There are no known photographs of the entire springhouse. (Photograph by Jim Brand, MM.)

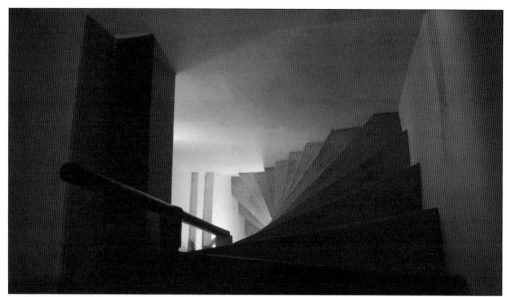

SECRET SPRING HILL STAIRCASE, 2016. When Spring Hill's main home was completed in 1821, several places became potential hiding places for fugitives. A secret staircase provided escape from the basement kitchen to the servants' quarters on the second floor, with no door or window on the first floor. Once there, legend says fugitives hid in a small cupboard or the attic crawlspace, seen below. Household staff moved a heavy barrel in front of the doors to protect them. (Photograph by Mandy Altimus Pond.)

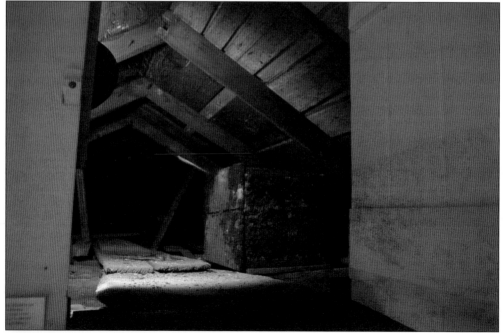

SPRING HILL ATTIC WITH RE-CREATED BEEHIVE, 2016. Thomas and Charity Rotch were dedicated to the abolition movement and therefore did not want to use slave-produced cane sugar from the Caribbean. They used maple sugar or honey from a hive of bees maintained in the attic. (Photograph by Mandy Altimus Pond.)

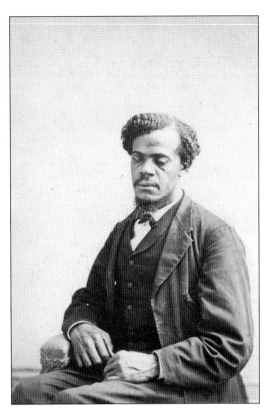

UNIDENTIFIED AFRICAN AMERICANS, MASSILLON, C. 1865. Many former slaves found refuge in the welcoming communities of Massillon and Kendal. These unidentified African American men posed for portraits in Martha Fletcher's photography gallery in the early 1860s. Because portraits were costly at that time, these men likely had good jobs. They may have been carriage driver Holson Eauches, or hotelier Jerry Clemmons, who reached Massillon in September 1828. Clemmons, who could neither read nor write, was hired by Robert Folger to manage the Commercial Inn. Clemmons owned a home on lot 55 in Kendal. He served in the Civil War and died in 1865. (Photographs by Martha M. Fletcher, both MM.)

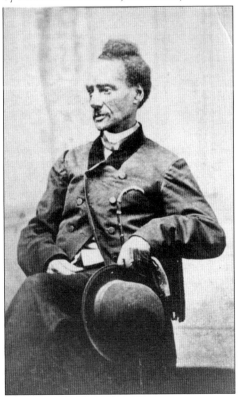

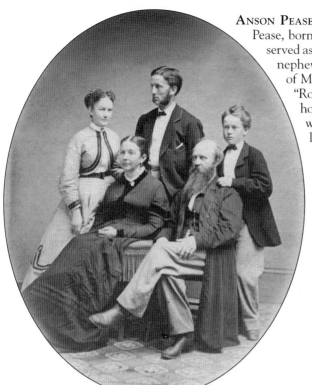

ANSON PEASE FAMILY, C. 1865. Lawyer Anson Pease, born in 1819, married Eliza Per Lee and served as deputy sheriff. Anson Pease was the nephew of Samuel Pease, the first mayor of Massillon. Previous to building their "Roanoke" home, they lived in a double house on Oak Street Southeast, shared with the Edwin Jarvis family. From left to right are Mary, Eliza, Abraham Per Lee, Anson, and Edmond Noxon Pease. (Photograph attributed to Martha Fletcher; MM, gift of W.W. Pease, 76.39.1.)

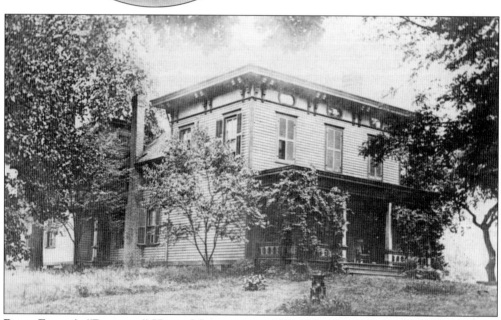

PEASE FAMILY'S "ROANOKE" HOME, MASSILLON, C. 1870. The Anson Pease family moved into their "Roanoke" home in 1852. Their servant was Sidney Powell, a runaway slave. She named the house "Roanoke" because of its resemblance to the home from which she escaped in Roanoke, Virginia. When Powell discovered her master was on her trail, the Pease family sent her to Canada to safety and freedom. (MM, gift of the Karl Spuhler Estate, 91.7.1873.)

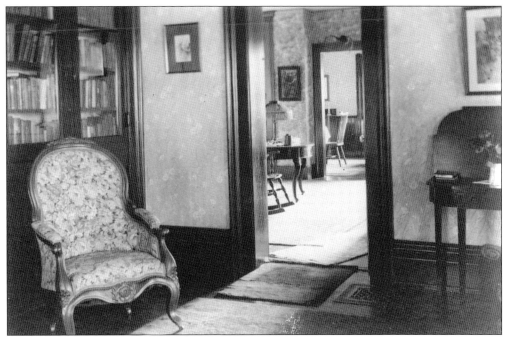

"ROANOKE" SITTING ROOM, C. 1920. "Roanoke" served as an Underground Railroad station. Photography studios were the main places to capture images, and cameras were too expensive for the average citizen. Therefore, interior photographs of homes in the 1800s are rare. This view provides a glimpse of the furnishings of the Pease family's home. (MM, gift of Ruth Pease Schiefer, BC 2277.2.)

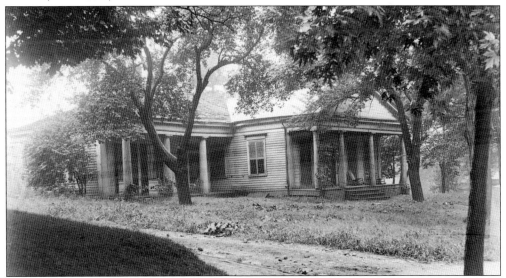

JAMES BAYLISS HOME, C. 1890. Bayliss built this home on Main Street in Massillon in 1835. According to an interview, his family welcomed fugitives, using an expansive wooded backyard for cover. Runaways came north on the canal and towpath and took that waterway to Canada by way of Cleveland. The house was moved to Water Street Northwest in the early 1900s. The house still stands today, though it is missing many of its additions. (Photograph by George McCall, MM, gift of Dan Douglass, 92.99.83.)

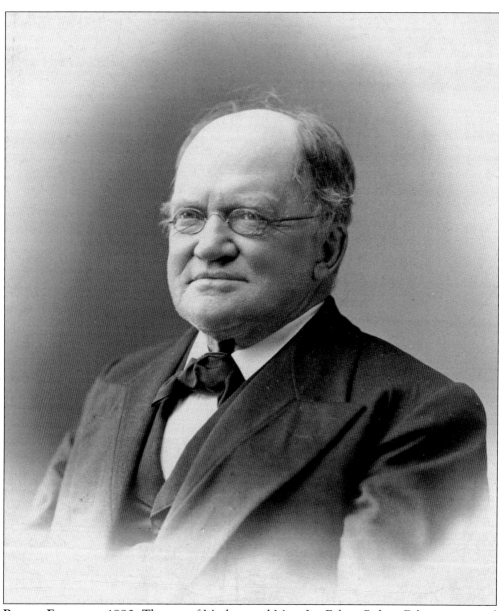

ROBERT FOLGER, C. 1880. The son of Mayhew and Mary Joy Folger, Robert Folger was named a Massillon Underground Railroad supporter in Siebert's book *Mysteries of Ohio's Underground Railroad*. Presumably, he took over the protection of fugitive slaves from his father, Mayhew Folger, who opened the Commercial Inn hotel on the northwest corner of Main and Erie Streets, just a few months before he died suddenly in 1828. Robert became the hotel's proprietor and enlisted Jerry Clemmons, a black man, as manager. Heavily involved in the community, Folger, a prominent lawyer, was justice of the peace for the village of Massillon and served as Massillon's mayor in 1861 and from 1864 to 1866. Folger was also a member of Sons of Temperance and Friends of Temperance and hosted meetings at the Commercial Inn. Massillon Temperance Society's Home of the Old Missionary Division number 520 was organized on August 31, 1857. Members pledged alcohol abstinence, paid 10¢ every three months, and met every Tuesday. Any member found in violation would be expelled, or members could leave at any time. (MM, BC 2363.2.)

TEACHER BETSEY MIX COWLES, C. 1850. Betsey Mix Cowles was one of the original female graduates of Oberlin Collegiate Institute, the first college in the United States to welcome women. Cowles was one of the first teachers at Massillon's Union School when it opened in 1848. Black Laws allowed African American children to attend publicly funded schools unless there were complaints from parents or voters. She encouraged her only black student to remain in class, despite a petition that was submitted to bar blacks from Massillon schools. Unfortunately, Cowles lost the battle. (Photograph by Abel Fletcher, Seaver Center.)

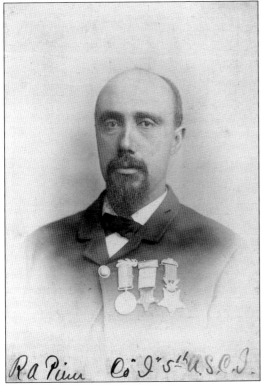

ROBERT PINN, C. 1876. Robert Pinn (1843–1914) was born a free man in Perry Township. His father, William Pinn, escaped slavery and settled in Ohio, marrying Zilphia Broxton, a white resident. Robert Pinn studied law with Robert Folger and became the first African American lawyer in Stark County. During the Civil War, Pinn enlisted in the 5th Colored Infantry in 1863. He was wounded three times in the Battle of New Market Heights in 1864 but insisted that his men carry him to the front lines to lead the troops. He received the Congressional Medal of Honor for his bravery—one of only four African Americans in Ohio to earn that medal in the Civil War. (MM, gift of Ralph Stern, 68.31.38.)

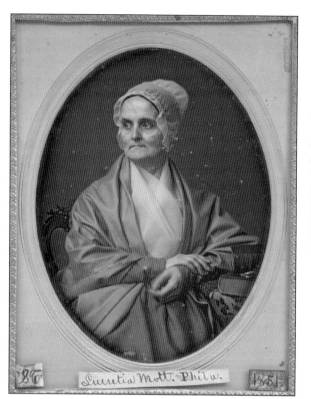

LUCRETIA COFFIN MOTT, 1851. Lucretia Mott fought for women's rights and slave emancipation. Her parents lived in Kendal for a short time. She was a niece of Mayhew and Mary Joy Folger. She delivered a lecture in Massillon in 1847 and reportedly posed for a daguerreotype in Abel Fletcher's studio during her visit. Though many portraits of Lucretia Mott exist, the portrait by Abel Fletcher has never been verified. (Photograph by Marcus Aurelius Root, National Portrait Gallery, Smithsonian Institution, NPG.2009.32.)

CAROLINE MCCULLOUGH EVERHARD (1843–1902), C. 1860. Everhard attended Lucretia Mott's inspirational 1847 lecture in Massillon and was a student of Betsey Mix Cowles's class at Union School. Everhard later became an activist who fought for women's rights and helped to found the Massillon Woman's Suffrage Association and served as president of the Ohio Suffrage Association. She was admired for her numerous public charitable works, which included serving Charity School of Kendal, Massillon Humane Society, Massillon High School Alumni Association, and McClymonds Public Library. (MM, museum purchase.)

Three

THE DUNCANS ESTABLISH MASSILLON

In 1817, James and Eliza Duncan arrived in Stark County, living on Estramadura Farm a few miles south of Kendal. Duncan turned his eye to land southwest of Kendal, where he purchased acreage to secure his place along the Tuscarawas River.

On the Ohio frontier, pioneers looked to improve lives by enhancing means of travel, business opportunities, and availability of goods. The Erie Canal was a success in New York State, and it became apparent that such a waterway could advance commerce in the young state of Ohio. The Ohio Board of Canal Commissioners was established in 1822, and they began surveying possible canal sites.

In order to make his new village of Massillon a success, Duncan needed to first win the bid for the Ohio and Erie Canal. The state legislature selected the basic route for the canal, but Duncan had to lobby to build it on the east side of the Tuscarawas River, in competition with William Henry's settlement on the west side. Duncan won the approval by offering a third of his land to the state. Duncan was in charge of constructing 44 sections of the canal, covering 27 miles from Summit Lake in Akron to just south of Navarre.

James Duncan was a visionary who saw the area as a promising new settlement. His canal-related businesses soon overshadowed Kendal, especially after Duncan had the State Road moved to Main Street through the heart of Massillon, running right past many of his businesses. Duncan laid out 165 lots parallel to the Tuscarawas River and the plat was officially recorded on December 6, 1826.

Irish and German immigrants flocked to the new town for opportunities to construct the canal and its locks between 1826 and 1828. Duncan paid 30¢ a day and a jigger of whiskey. Three basins provided boat access to downtown warehouses, hotels, and businesses. The Wellman Warehouse was famous for its "cash-for-wheat" policy that brought farmers from several nearby counties to sell their goods. On August 25, 1828, the first canal boats arrived in the Port of Massillon, and the legendary "Wheat City" was born.

JAMES DUNCAN (1789–1863) AT AGE 30, C. 1900. Duncan ran away from his guardian, a strict aunt, Mrs. Baldwin, and served on a merchant marine ship. He left his sea adventures for pioneer life in the 1810s. Granddaughter Mary Ely Miller recounted that Duncan was known as the "handsomest man in New Hampshire," with the "two brightest blue eyes." Duncan played a large role in the establishment of banks, industries, and St. Timothy's Episcopal Church. (Painting by Jacob Becker, MM, BC 2355.1.)

ELIZA VILETTE (1796–1878), 1816. Vilette was a niece of Charles Hammond, an early *Cincinnati Gazette* editor. David Boudon (1748–1816) painted her portrait while traveling through West Virginia. Vilette married James Duncan in 1816, and as they left the wedding ceremony, they traveled in a shay wagon pulled by cows. She tumbled out the back onto mayweed and ruined her white shawl. Eliza Duncan is credited with naming the city of Massillon for Jean-Baptiste Massillon, a French cleric in the court of King Louis XIV. (Painting by David Boudon, courtesy of the Frick Art Reference Library.)

ESTRAMADURA FARM, C. 1950. James Duncan purchased the Estramadura Farm and home on South Erie Street in 1816 from William Dickinson, a Merino sheep farmer. When Duncan fell into financial hardship in the 1830s and 1840s, his land was sold to Hiram Wellman. In 1898, the land became the site of Massillon State Hospital, and the home was razed in 1956. (Photograph by James Young; MM, gift of Lois McAllister, Ralph Cornell Estate, 07.45.99.)

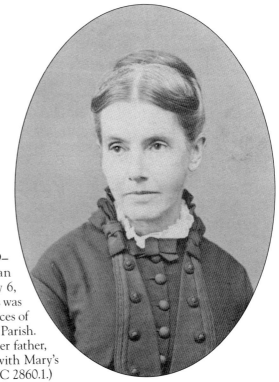

MARY GREENE DUNCAN REYNOLDS (1819–1899), C. 1870. Mary Greene Duncan married James Lusk Reynolds on January 6, 1837, with Rev. John Swan officiating. This was the first wedding recorded under the auspices of the newly formed St. Timothy's Episcopal Parish. The ceremony was held in the home of her father, James Duncan. James Reynolds worked with Mary's father's Massillon Iron Company. (MM, BC 2860.1.)

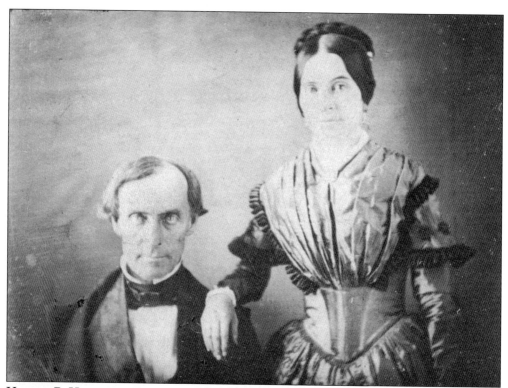

HERMAN B. HARRIS AND LOUISA M. DUNCAN MCCLARY HARRIS, C. 1850. In 1832, the McClary-Harris marriage, the first Episcopal wedding in Massillon, was held in the home of her uncle, James Duncan. Rev. Intrepid Morse of Steubenville officiated the ceremony. Herman Harris helped to organize the Massillon Iron Company in 1832 with Joseph Hogan, Jesse Rhodes, and James Duncan. Harris died at sea on his way to California in 1851, likely headed west for the Gold Rush. (MM, BC 2860.3)

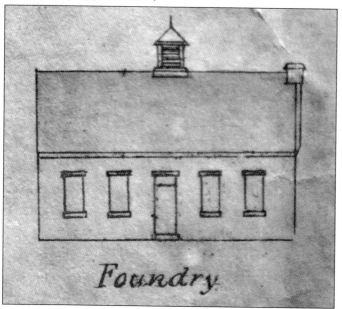

MASSILLON FOUNDRY, 1837 MASSILLON MAP. James Duncan's Massillon Iron Company began as an iron blast furnace in 1833 along the Sippo Creek. Duncan rerouted part of the Ohio and Erie Canal to run his rolling mill in 1838, forming Lock Five-A, south of Walnut Road. Investors pulled out during the financial panic of 1837 and the company folded but was revived as Massillon Furnace and Iron Company. (Detail, SHHH.)

DUNCAN'S MILL, C. 1950. James Duncan purchased this lot from John Scott in 1811 and immediately began construction on a three-story grain-processing mill with a full basement and loft. Duncan also built a sawmill, flour mill, and tannery. He partnered with Charles K. Skinner and added a woolen factory about 1828. A Sippo Creek mill race through the lower level of the building powered the mill machinery. (MM, gift of the Karl Spuhler Estate, 91.7.3080.)

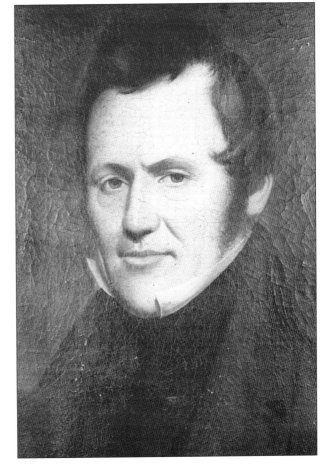

PAINTING OF CHARLES K. SKINNER (1792–1875), C. 1812. Charles K. Skinner worked for Thomas Rotch in New Bedford, Massachusetts, and followed him to Ohio in 1811. Skinner worked in Rotch's woolen mill until he pursued a milling partnership with James Duncan in 1818, which eventually eclipsed Rotch's mill in Kendal. He served on the first vestry of St. Timothy's Church and was president of the Bank of Massillon. Skinner retired by 1860. (MM, BC 2546.)

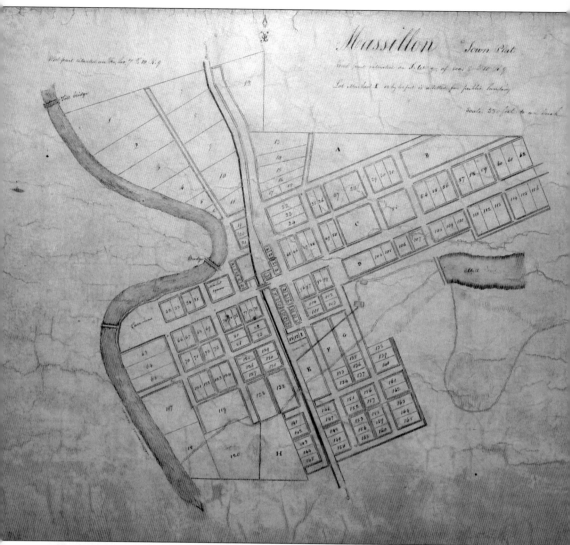

HAND-DRAWN COPY OF THE ORIGINAL PLAT OF MASSILLON, DECEMBER 6, 1826. After Duncan signed contracts with the state to build sections of the Ohio and Erie Canal on January 18, 1826, he purchased land for his village and laid out 165 lots. *The Ohio Repository* ran advertisements in June 1826 for residential and business lots for sale in the new town of "Massilon." Joshua Henshaw surveyed the area and created a map in May 1826. Duncan planned various canal basins and docks throughout the town to encourage growth of canal-based commerce in his new community. Original notes along the Tuscarawas River include William Henry's toll bridge at the top and an Indian ford at the tip of the hairpin turn. In 1832, Duncan purchased land with Charles K. Skinner and Arvine C. Wales that linked the towns of Kendal and Massillon. (SHHH.)

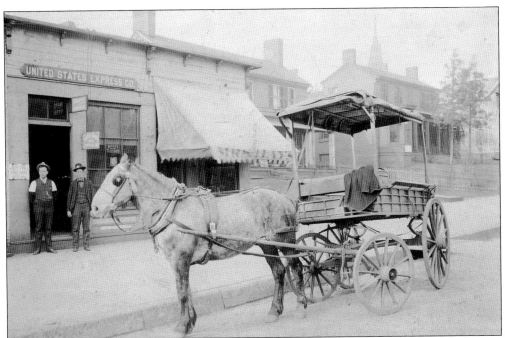

UNITED STATES EXPRESS COMPANY, C. 1880. James Duncan's third home, seen at the far right, was built on East Main Street in 1823, with a dry goods store in the east section and living quarters in the west, according to William Perrin. There are two extant photographs, this and another pictured on page 66. The building was razed in the 1890s to make way for the Schworm building and Grand Theater. (MM, gift of the Karl Spuhler Estate, 91.7.401.)

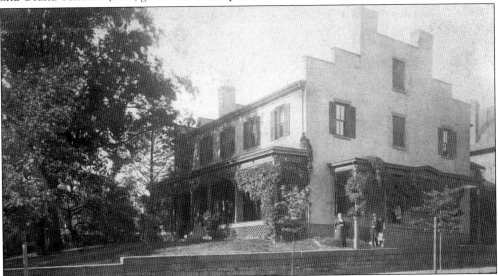

DUNCAN'S FOURTH HOUSE, C. 1880. Duncan's grand home at the northeast corner of Hill and East Main Streets was built in 1833. It overlooked his town of Massillon down to the Tuscarawas River. This home, given to the community in 1931 in Frank and Annie Steese Baldwin's wills, originally housed the Massillon Public Library and the Massillon Museum. It is now the local history room in the library. Pictured is homeowner Clara Baldwin Barrick and her son Frank Baldwin. (MM, gift of Miss Estaine Depeltquestangue, BC 2110.29.)

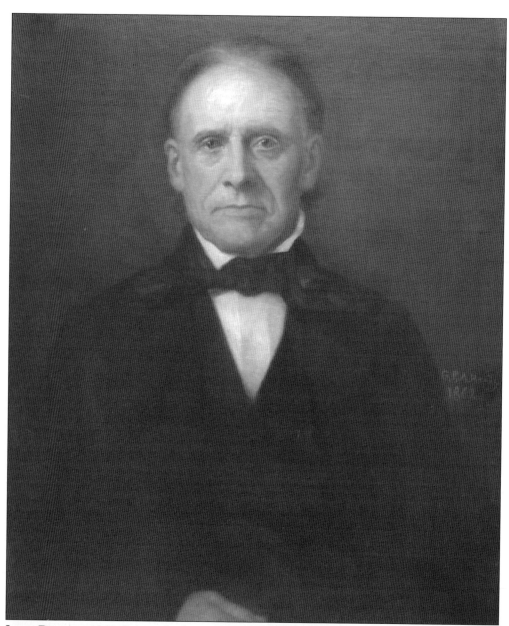

JAMES DUNCAN, 1862. During the financial panic of 1837, James Duncan lost large sums of money and his Massillon Rolling Mill Company folded. In 1841, he filed for bankruptcy. In 1848, Duncan started a new business venture near Marquette, Michigan, in the state's Upper Peninsula, as part of the Isle Royal Mining Company. He purchased 40 acres and built a steam-powered sawmill to provide wooden boards for a 14-mile plank road from Marquette to the Iron Mountains. This plank road helped in the development of the Lake Superior region, providing a path for men, supplies, and machinery to move more efficiently between the mines and Marquette. By 1862, Upper Michigan's harsh conditions took a toll on Duncan. After several months of illness, he died on March 15, 1863, in Chicago at the home of his daughter and son-in-law, Mary Greene and James Reynolds. (Painting by G.P. Healy, MM, gift of Mrs. Frederick Kellogg of Cambridge, Massachusetts, BC 2355.3.)

Four

WATERWAYS AND THE RAILROAD

Massillon's history is heavily tied to its waterways. Many settlers of Kendal and Massillon had been ship captains or employees in water-based industries. Many left the ocean for interior waters of the country.

Sippo Creek winds from the Sippo Lake, through Massillon, and terminates at the Tuscarawas River. From the rushing Sippo Creek's waterpower ran man-made mill races that fueled factories and businesses, including Thomas Rotch's and James Duncan's woolen mills and sawmills.

The Tuscarawas River provided a natural boundary between the US territories on the east side and the Wyandot, Delaware, and Ottawa Indian tribes on the west, as prescribed by the 1785 Treaty of Fort McHenry. In 1805, the Treaty of Fort Industry removed that boundary, claiming lands west of the river for the United States, which allowed settlement in the west.

Every spring, the hairpin turn of the Tuscarawas River in Massillon's downtown near the Ohio and Erie Canal flooded with heavy spring rains and melting snow. These floods continued yearly until the river was rerouted in the 1940s.

In 1828, the Ohio and Erie Canal opened in Massillon, providing an affordable way to buy and sell goods throughout the state. Several downtown landings provided access to wheat warehouses, dry goods stores, hotels, and other amenities.

The Ohio & Pennsylvania Railroad arrived in 1852 and diverted business away from the canal. Massillon's canal-based economy was slow to accommodate the railroad, and many businesses closed by the 1860s. The canal served passenger traffic into the late 1800s and eventually faded from existence after the devastating flood of 1913 washed away much of the canal banks. Many remaining parts of the canal were removed by the end of the 20th century, though sections of canal bed still lie under Massillon buildings today.

Always a dreamer, James Duncan first envisioned the railroad in Massillon in 1832, working with Charles Skinner and Arvine Wales to investigate its possibilities, making plans for its construction through Northeast Ohio. Dwight Jarvis Sr. and David K. Cartter urged Pennsylvania Railroad magnates in Pittsburgh to extend the railroad to Massillon in 1852. The trip from Pittsburgh to Massillon took eight and a half hours. The Pennsylvania Railroad was Massillon's first railroad; the Baltimore & Ohio and the Wheeling & Lake Erie lines served the town by the 1870s.

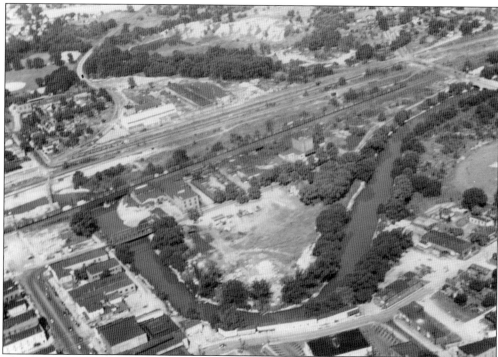

AERIAL VIEW OF DOWNTOWN MASSILLON AND TUSCARAWAS RIVER, C. 1945. The natural course of the Tuscarawas River looped into downtown Massillon, where buildings grew around the river. The hairpin turn was the source of massive flooding throughout the city's history, the worst instances occuring in 1904, 1913, and 1935. (MM, gift of the Karl Spuhler Estate, 91.7.2879.)

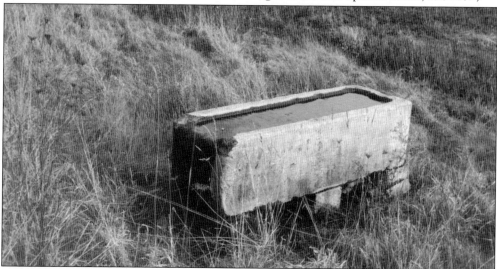

STONE WATERING TROUGH, C. 1940. When Thomas Rotch settled Kendal, Ohio, he claimed a hill with springs on it—appropriately naming it Spring Hill. Wishing to provide the village with drinking water, he began construction of an aqueduct in 1816 and completed the works in 1818. The Kendal Aqueduct Company maintained a series of reservoirs, conduits of hollowed logs, and cisterns. The conduits delivered water to cisterns and troughs, like this one, located near Hugh Northeast and Plum Street. (MM, gift of the Karl Spuhler Estate, 91.7.3266.)

CANAL DREDGING, C. 1890. The local sections of the canal, built between 1826 and 1828, required maintenance, paid for by tolls. Its banks suffered many collapses, such as one that occurred during the 1848 flood, which necessitated rebuilding the banks and dredging the channel to keep its depth. Buildings sat directly on the canal banks, which provided canawlers easy access from their boats. (MM, BC 3962.6)

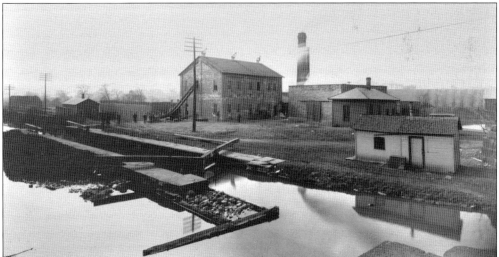

MASSILLON PAPER COMPANY AND CANAL, C. 1900. The Ohio and Erie Canal featured several basins in which boats could dock and turn, seen at left. The canal ran north and south with two angled canal gates holding the water at a lock. The Massillon Paper Company was built from the ashes of the Massillon Flouring Mill in 1866. (MM, 73.30.1)

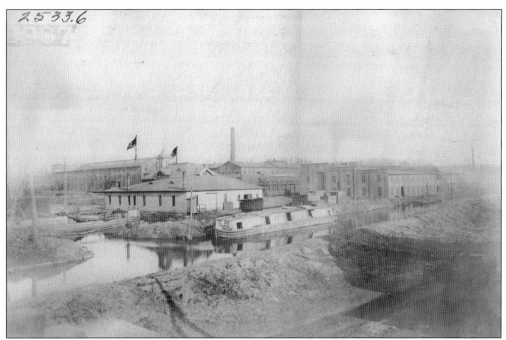

THE RUSSELL & COMPANY, LOOKING SOUTHEAST, 1888. The Russell & Company was a very successful business that fully harnessed the power of the canal and railroad for its shipping needs. Its large buildings lined several blocks along the canal. The company was quick to add railroad spurs to their grounds for additional transportation options. (MM, BC 2533.)

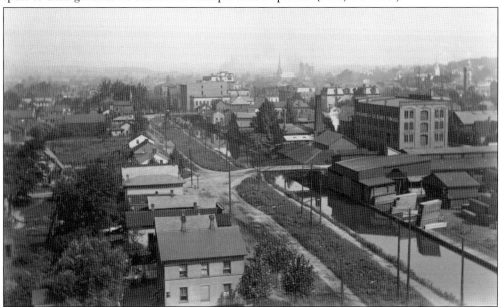

OHIO AND ERIE CANAL, LOOKING NORTH FROM WALNUT ROAD C. 1885. Several houses and saloons faced the Brown lumberyard, seen at right across the canal. North of that stood Hess-Snyder Company's four-story factory and warehouse. Businesses used the canals to ship their goods across the state of Ohio and beyond. On the west side of the canal were residences and businesses, including bars for weary canal travelers. (MM, gift of the Karl Spuhler Estate, 91.7.2640)

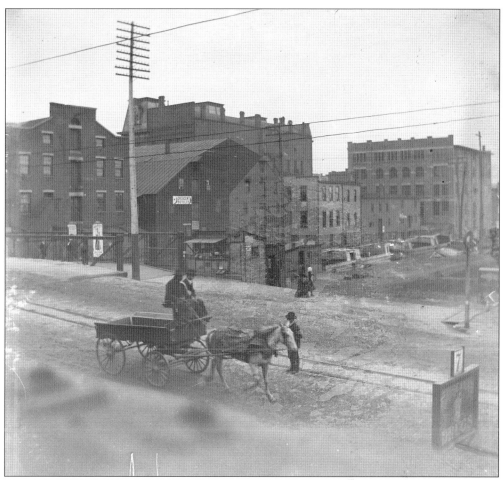

DOWNTOWN MASSILLON, LOOKING SOUTHEAST, C. 1890. This never-before-published view of the canal shows the many businesses that lined the waterway. At the right is the public landing, the main entry point for canawlers into the city. (MM, museum purchase.)

PUBLIC LANDING ALONG CANAL STREET, C. 1890. The center building has an iconic roof ornamentation that can be seen in many photographs of the Ohio and Erie Canal, which ran parallel to Canal Street. The Franklin House is seen at left behind the tree. On the east side of the street was the public landing that provided the main location for business, loading and unloading, and mooring boats. (Photograph by Stanley Baltzly; MM, BC 2308.6B.)

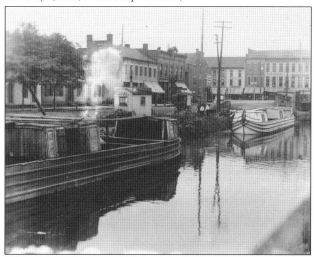

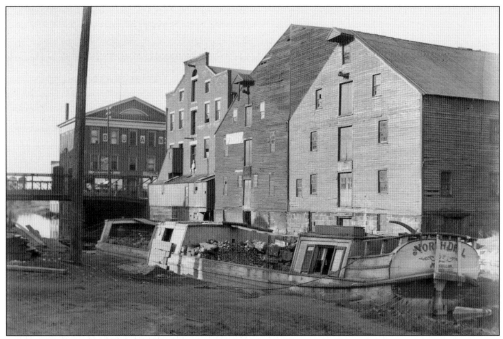

NORTHDELL CANAL BOAT AT THE PUBLIC LANDING, C. 1890. Canal warehouses lined the waterway, such as the Wellman-Atwater warehouse on the east side, just south of Main Street. Its expansion from the original Watson Warehouse is visible, appearing as a double-wide structure. The building was torn down in 1933, as no one could find a use for such a massive structure in the 20th century. (Photograph by George McCall, MM, gift of Dan Douglass, 92.99.110.)

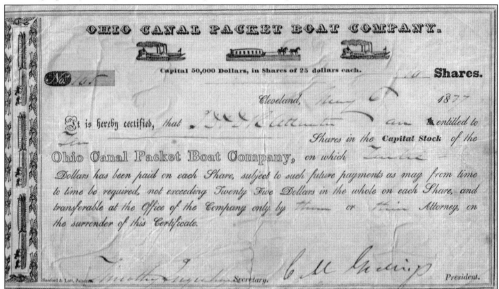

CERTIFICATE FOR OHIO CANAL PACKET BOAT COMPANY, 1837. Warehouse operators Joshua D. and David R. Atwater purchased 10 shares in the Ohio Canal Packet Boat Company on May 6, 1837. Packets provided a popular travel option for the four-mile-per-hour day trip to Akron, Canal Fulton, or Zoar. Passengers paid $3 for a two-day trip to Cleveland. (MM, gift of Mrs. W.K. Atwater, BC 2135.1.)

COL. HIRAM B. WELLMAN, C. 1860. Col. Hiram B. Wellman came from New York to Massillon in 1835. He and his brother Marshall D. Wellman became warehouse proprietors and established a "cash for wheat" policy, which launched Massillon's nickname of the "Wheat City." This brought farmers from surrounding counties to Massillon for the best wheat prices. The canal enabled the Wellmans to send their agricultural products to many faraway towns. The Wellmans left Massillon in the 1850s because the railroad was more reliable and offered faster transportation. Mr. Whitehead carried on the business. (MM, gift of the Massillon Public Library, 83.39.197.)

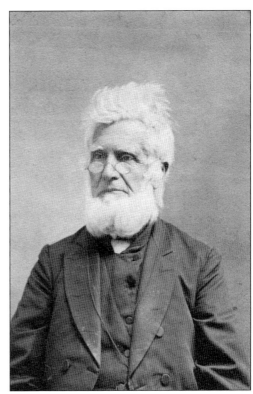

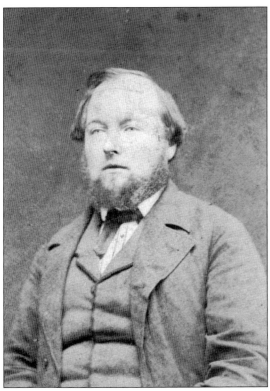

DAVID ATWATER, C. 1860. Twin brothers Joshua and David Atwater came to Massillon and established a grocery and provision business in 1832. Joshua Atwater died in 1840, but David continued the business, merging interests with the Wellmans. Farmers came to town with their wagons of wheat, and dealers met them to inspect and bid on the grain. According to Mrs. Barton (Georgia) Smith, an auction block was located on the southwest corner of South Erie Street and Charles Avenue Southwest. (MM, gift of Nancy Kerr, 11.015.005.)

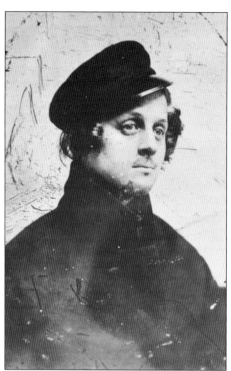

UNIDENTIFIED CANAL BOAT CAPTAIN, C. 1860. Previous Museum volunteers and staff believed this portrait to represent J.O. Osbourne. Other captains of the mid- to late 1800s, as named by Shorty Roan, were Asa Cutler, Jack McGraw, Hosea Eaches, George Castelman, Tom McConnell, and John and Bill Fry, who also owned a dry dock where canal boats were rebuilt and repaired, on the west side of the canal, north of Cherry Street. (Ambrotype photograph by Martha Fletcher, MM, BC 2679.3.1.)

CANAWLER IRA "SHORTY" ROAN, C. 1905. Known as the last canawler, Roan enjoyed a long career on canal boats. He arrived in Massillon with his father aboard the *Colonel Jarvis* canal boat in 1868. Roan was in charge of the mules for more than a decade. He made a habit of jumping off the boat at the Cherry Street bridge to pay tolls and quickly jumping aboard before his boat reached Main Street. (Photograph by George McCall, MM, gift of Dan Douglass, 92.99.121.)

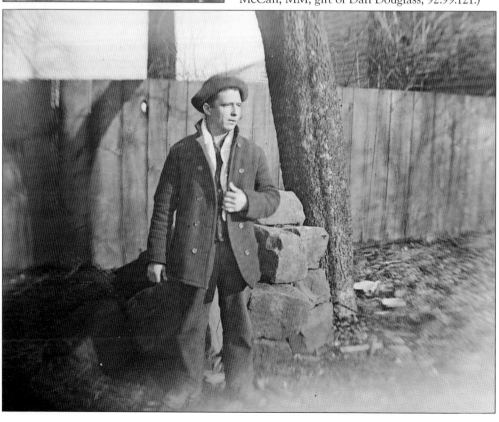

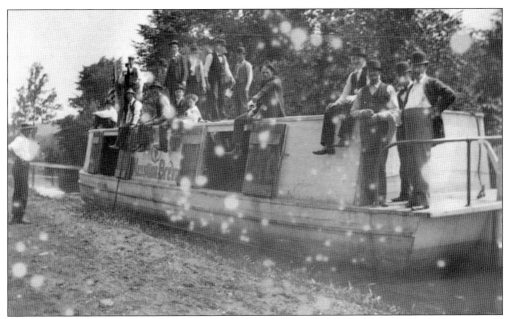

PARTY SITTING ON CANAL BOAT AT THE PUBLIC LANDING, C. 1890. Canal boat employees were left with free time while trade deals were made or after a boat was loaded and unloaded of its cargo. This boat has "Massillon Brews" painted on the side, suggesting it shipped beer along the canal, functioned as a floating bar, or provided an advertisement. (Photograph by A.J. Miller, MM, BC 2684.3.)

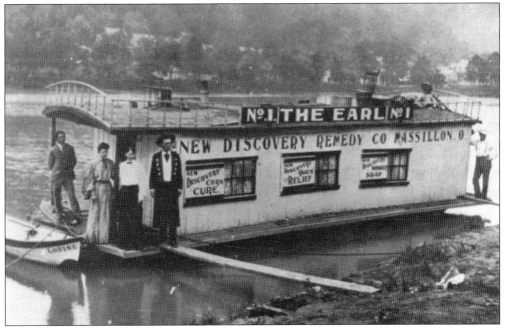

NUMBER ONE THE EARL, C. 1890. Throughout the 1800s, medicine was just becoming a modern science. Salesmen across the country claimed to have miracle elixirs that could fix various maladies. Here, a family claims a "new discovery remedy," which they sold from their boat. (MM, gift of the Karl Spuhler Estate, 91.7.3146.)

CANAL BOAT IN LOCK NEAR WALNUT ROAD, C. 1895. As many as 3,000 canal boats traveled on the Ohio and Erie Canal each year. They were limited to a speed of four miles per hour. Change in elevation along the canal forced engineers to devise a lock system to move boats up and down the waterway through Ohio. These locks also provided entrepreneurs an opportunity to charge tolls to open the gates. (MM, gift of Dan Douglass, 90.25.643)

CANAL TOLL COLLECTORS BUILDING, LOCK 4, CANAL FULTON, C. 1950. The canal was expensive to build and maintain. A final payment for five sections of canal totaling two and a half miles was more than $22,000 in 1830. To offset this cost, each boat paid a toll. (MM, gift of the Massillon Area Chamber of Commerce, 92.98.814.)

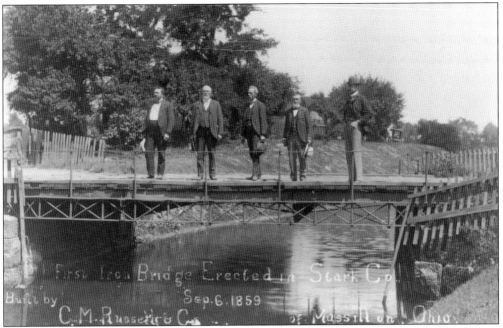

FIRST WROUGHT IRON BRIDGE, C. 1870. The first wrought iron bridge in Stark County was installed at Third Street Southeast in Canton, across the Nimishillen Creek. It was installed in 1859, designed by Joseph Davenport and built by The Russell & Company. (MM, 82.26.)

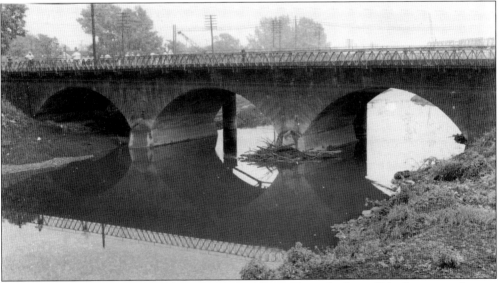

MAIN STREET BRIDGE, C. 1920. About 1813, William Henry built a toll bridge to supplement his income along the State Road that crossed into Cherry Road across the Tuscarawas River. He founded the Kendal Tuscarawas Bridge Company in 1816. Some protested his monopoly on river crossing and built their own free bridge at Main Street. It was sabotaged shortly after its completion in 1818. Perrin's history claimed that David Andrews was paid with a fiddle, a silver watch, and a quart of whisky to destroy the free bridge. Henry rescinded his fees. The wooden free bridge was rebuilt, then replaced in 1853 by the stone bridge seen here. (MM, gift of the Karl Spuhler Estate, 91.7.663.)

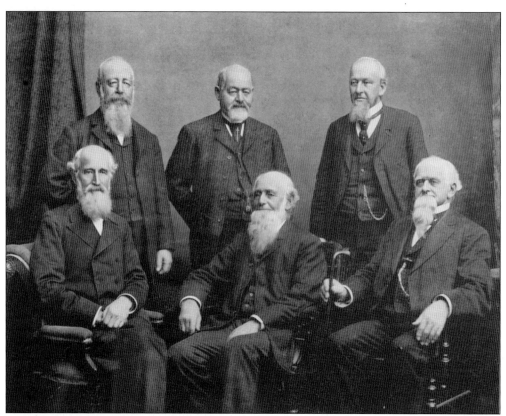

Russell Brothers, 1890, and The Russell & Company, 1865. Pictured from left to right are (standing) Thomas H., George L., and Allen A; (seated) Joseph K., Nahum S., and Clement. In 1838, Charles M. (not pictured), Nahum, and Clement started their general carpentry trade. It began in a two-story frame building, where they ran machinery by horsepower. They built houses, furniture, plows, threshers, and burial cases. The demand for agricultural implements grew, and they incorporated on January 1, 1842, as C.M. Russell & Co. Construction of the brick foundry began in 1845, and it grew into a sprawling campus of various departments. The remaining Russell brothers joined the business, and they expanded their products to include mowers, reapers, and railroad cars. (MM, BC 2533.1.)

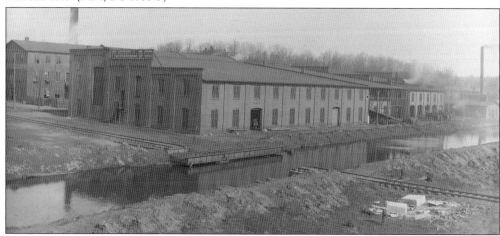

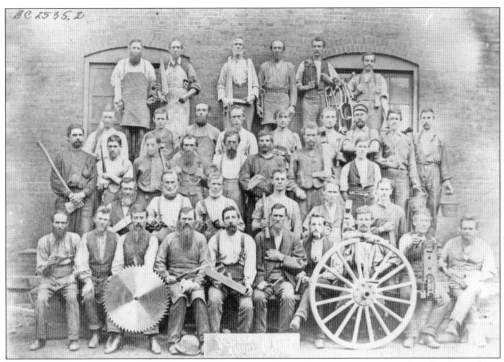

THE RUSSELL & COMPANY MACHINE SHOP, WOOD SHOP, SEPTEMBER 1873. The Russell & Company employed a large percentage of the town's population. Different shops worked together creating engines and equipment to be sold across the world. Departments included machinery, painting, engineering, pattern-making, blacksmiths, brass, iron and tin foundry, boilers, tools, repair, testing, carpentry, erecting, mounting, and administrative. (MM, BC 2535.2.)

JOSEPH DAVENPORT (1815–1912), 1887. Joseph Davenport came to Massillon in the 1850s and partnered with The Russell & Company to produce railroad cars. He and his brother Charles were responsible for building the first American-style railway coaches with the aisle in the center in the 1830s, and in 1840 he invented the cowcatcher for the front of trains to plow snow. In 1869, he founded the Massillon Iron Bridge Company, responsible for the first cantilevered bridges in the United States. He continued to invent machines throughout his life, including steam cars and a model airship at the age of 94. (MM, BC 3934.1.1.)

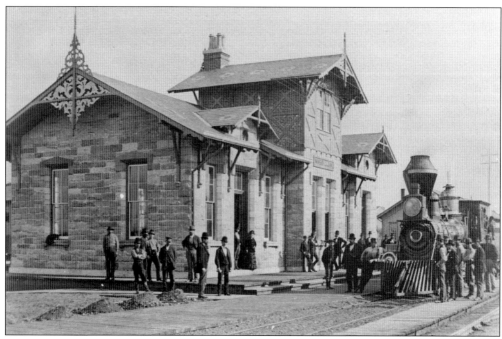

MASSILLON TRAIN STATION, C. 1870. James Duncan first proposed a railroad in 1832, but it was not until March 11, 1852, that the Ohio & Pennsylvania Railroad finally arrived in Massillon. A celebration was held to greet the special train. Artillery companies fired rounds, thousands of citizens waved handkerchiefs and cheered, and 500 Union School children sang. The train seen here has a cowcatcher on the front, an invention of Joseph Davenport. (MM.)

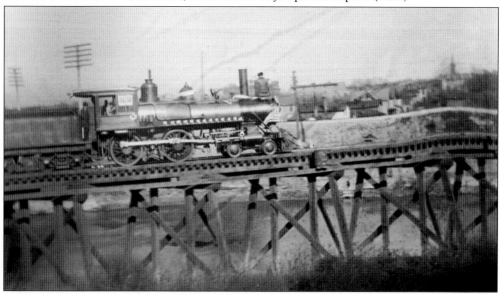

4-4-0 LOCOMOTIVE ON TUSCARAWAS RIVER TRESTLE, MASSILLON, C. 1890. The canal era began to wane with the coming of the railroads in the 1850s. Massillon struggled to shift its canal-based economy to that of train travel. Improvements included hotels near the railroad depot. This bridge near Massillon depicts some of the early railroad pathways through the state. (Photograph by A.J. Miller, MM, gift of Dan Douglass, 92.99.90.)

Five

EARLY MASSILLON BUSINESSES

Massillon businesses grew rapidly with the introduction of the Ohio and Erie Canal in 1828.

Provisions, groceries, clothing, and other dry goods were transported by the canal from across the country. Canal boats carried Massillon products to ports for shipping to distant cities. In 1846, historian and researcher Henry Howe visited Massillon and described in his book *Historical Collections of Ohio*: "It is very thriving and is one of the greatest wheat markets in Ohio. At times Main Street is almost completely blocked by immense wagons of wheat and the place has generally the bustling air of business." Massillon at the time had approximately 2,000 residents.

Most businesses that opened between 1812 and 1860 were small operations, often run by one family. As these businesses grew, they sometimes combined with similar businesses to enhance service and product selection.

Abel Fletcher's photography studio opened in 1843, early in the history of the medium, documenting many of Massillon's early citizens and businesses.

The Union Branch of the State Bank in Ohio was organized in 1847 with Dr. Isaac Steese as its president.

Gradually, Kendal and Massillon transitioned from an agricultural economy to an industrial, commercial, and service-oriented community. Newspaper publishers ran advertisements for businesses from the 1830s onward.

Challenges arose when the 24 years of canal-focused businesses necessarily shifted to railroad-based commerce. The speed of the railroad superceded the slow-moving canal boats. Businesses hesitated to change; more than 100 businesses closed between 1853 and 1860. Many businessmen moved on in the 1850s, some seeking gold in California, others founding cities on the West Coast.

In this era, many long-standing businesses were formed, including Hess-Snyder Company (1861), the Russell & Company (1842), Hotel Conrad (1840s), and commercial coal mining (1833).

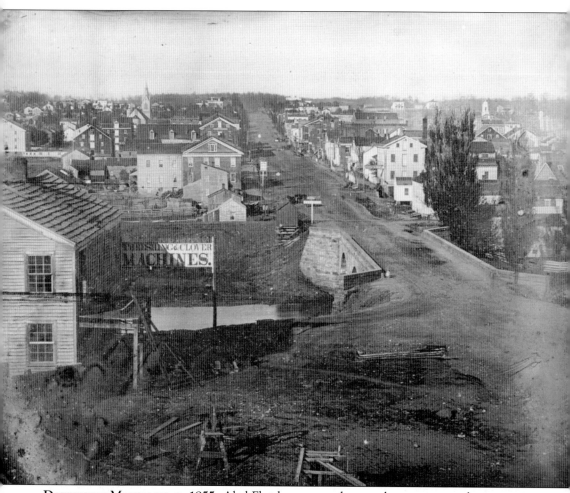

DOWNTOWN MASSILLON, C. 1855. Abel Fletcher captured an outdoor scene as a daguerreotype about 1855, providing the earliest existing glimpse of Massillon's downtown. This photograph was taken just west of the Main Street bridge. A canal boat can be seen toward the top left corner. The wooden bridge built for Main Street in the 1820s to cross the Tuscarawas River was replaced in 1853 by the stone bridge, seen at the middle of this photograph. The stone bridge was widened in 1893 and replaced with a viaduct in 1949. Before American settlers came to this area, this crossing was used by American Indians to ford the low point in the Tuscarawas River. (Daguerreotype photograph by Abel Fletcher, Seaver Center.)

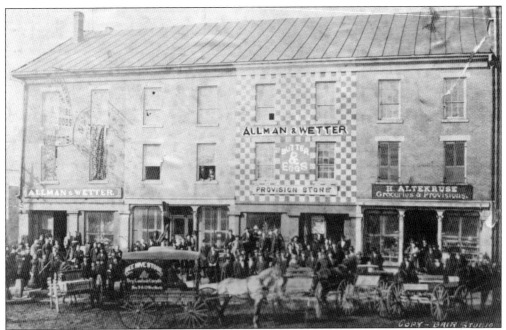

DOWNTOWN MASSILLON BUSINESSES AT THE NORTHEAST CORNER OF MAIN AND CLAY STREETS, C. 1872. This block was likely built in the 1840s. It housed Allman and Wetter provisions and clothing and H. Alterkruse groceries and provisions. The block was lost to fire in 1898 when the Allman and Putman Bee Hive Cash Store, later housed one block west, burned. (Photograph by Bair Studio, MM, gift of the Bessie Skinner Estate, 57.89.1.2.)

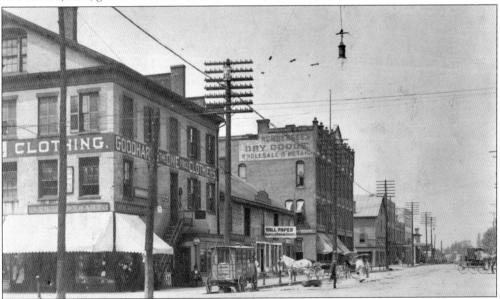

NORTHWEST CORNER OF ERIE STREET, LOOKING NORTH, C. 1880. Mayhew Folger's Commercial Inn stood on the northwest corner of Erie and Main Streets. It was featured in Henry Howe's 1846 sketch of downtown. The building housed several businesses, such as dry goods and clothing stores. To the north stood a wallpaper business. Buildings along the west side of North Erie Street lined the east bank of the Ohio and Erie Canal. (Photograph by Stanley Baltzly; MM, BC 2311.17.)

ABEL FLETCHER SELF PORTRAIT, C. 1843. Abel Fletcher was born in Richmond, Virginia, in 1820. A Universalist preacher, he had dabbled in photographic processes since he was 16 years old, creating optical lenses by hand. He moved to Massillon about 1843 to open a studio on South Erie Street. Fletcher died in 1890, never having been fully recognized for his contributions to photographic history or his rightful place among the pioneers. (MM, gift of Lillian Fletcher, BC 1813.1.)

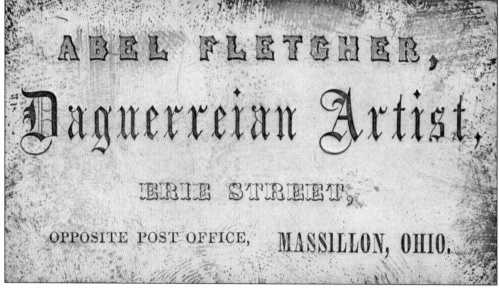

ABEL FLETCHER'S BUSINESS CARD, C. 1845. Advertisements promoted the studio as a "skylight Daguerrean room." Daguerreotypes are a single positive image developed directly onto a chemically treated metal surface. Fletcher devised a process for producing paper negatives, which allowed an image to be duplicated. Henry Fox Talbot was also experimenting with this process in England at the same time and is credited with inventing these negatives, called calotypes. (MM, BC 2678.)

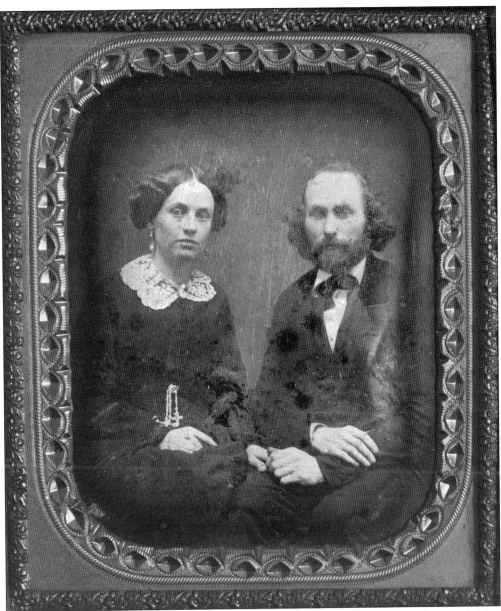

Martha Mary and Abel Fletcher, c. 1862. Since Fletcher was a pioneer in the new field of photography, he was forced to mix his own chemicals and processes. Unfortunately, one of his chemical concoctions of concentrated ammonia exploded in the darkroom, blinding him in 1859. He trained his wife, Martha, to work in the studio, and she was able to continue photographing, making her one of America's first female photographers. She operated the studio until 1866, when her health began failing. William Wilson took over the studio at that time. Abel traveled to Columbus for a stay in an asylum for the blind, where he learned to read and write. He relearned the trade of broom-making to render himself useful in society and to earn a living. He opened a store in the third story of the Wellman Block, where he made and sold his brooms and continued to write poetry, one of his lifelong passions. (Daguerreotype photograph by Martha Fletcher, MM, gift of Lillian Fletcher, BC 1813.2.)

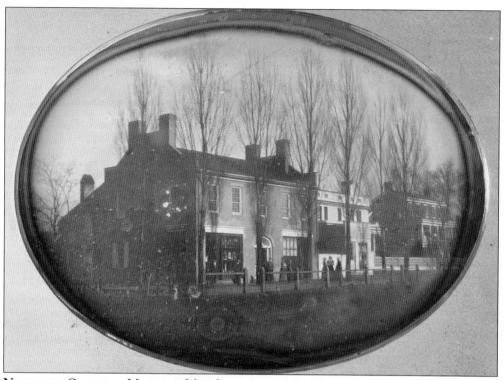

NORTHEAST CORNER OF MAIN AND MILL STREETS, C. 1850. Pictured from left to right are Joseph Coleman's jewelry store, Dr. Beriah Brooks's home (also known as the Silas A. Conrad house), and James Duncan's third house, which also doubled as a dry goods store. Coleman's store carried watches, clocks, jewelry, silverware, and optical goods. (Daguerreotype photograph by Abel Fletcher, MM, gift of Miss Annie Thomas, BC 1633.2.)

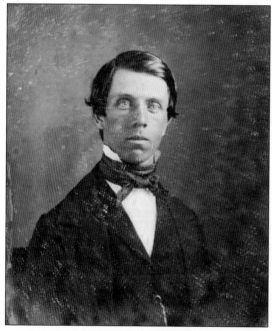

JOSEPH COLEMAN, C. 1845. Joseph Coleman was born July 4, 1823, in Suffolk, England. His family emigrated to Canada. Coleman arrived in Massillon in 1845 and apprenticed with Martin A. Withington (1806–1885). Coleman served on the town council before Massillon became a city. He served for 14 years as treasurer of the Massillon Cemetery Association and was on the board of directors at the Union Bank. (Daguerrotype photograph attributed to Abel Fletcher, MM, gift of Miss Annie Thomas, BC 1633.5.)

THOMAS MCCULLOUGH, C. 1860. At the formation of the Massillon Cemetery Association on February 16, 1846, McCullough was named president. He was elected as trustee of the City of Massillon upon incorporation in 1853. He was a partner in the 1869 Bucher Opera House, a vestryman and teacher at St. Timothy's Church, and a trustee of the Charity School of Kendal. Upon his death in 1885, his daughter, Caroline McCullough Everhard, was named to his director seat at the Union National Bank, making her the first female bank director in Ohio. (MM, museum purchase.)

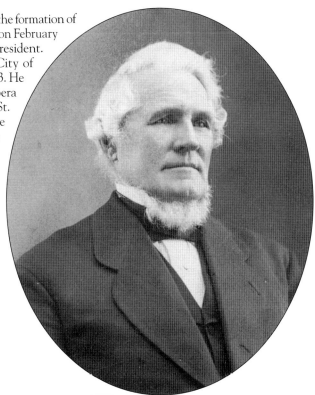

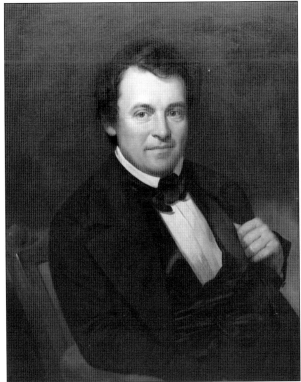

DR. ISAAC STEESE (1809–1874), c. 1850. Dr. Steese gave up his medical practice to become a banker, forming a State Bank of Ohio Union branch in 1847. It merged into the Union National Bank in 1865. Steese also helped to organize the Merchants National Bank, later known as First National Bank of Massillon. Respected for his knowledge of banking theory and business acumen, Steese died in 1874. (Oil portrait by Allen Smith; MM, gift of Edward Steese, BC 288.)

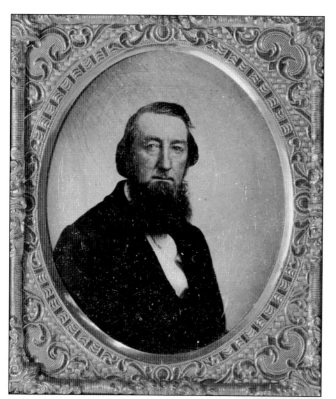

Tintype Portrait of Gustavus P. Reed, c. 1855. The Reeds were an early pioneer family in Kendal, Ohio. When business focus shifted from Kendal to Massillon, the Reeds followed. He started as a clerk in 1844 and eventually opened his own dry goods business next door. (MM, gift of Betty Spidel Buchwalter, 68.23.13.3.)

G.P. Reed's Fancy and Staple Dry Goods Store, c. 1860. Opened in 1856 at Four East Main Street, the store stood between Erie and Canal Streets. It was described in an 1884 *Massillon American* article as "filled to profusion in every department from the floor to the ceiling, every available foot of space being utilized." Among the items sold were silks, satins, shades, hosiery, gloves, underwear, jewelry, umbrellas, blankets, buttons, and upholstered goods. (MM, gift of the Massillon Public Library, 83.39.20.)

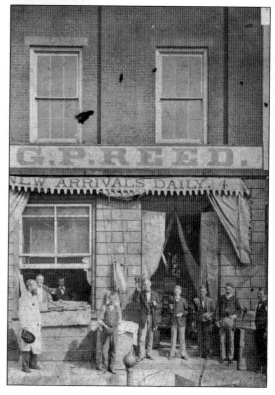

THE ENTERPRISE GROCERY AND PROVISION STORE, C. 1890. Herman Pietzcker started his business in 1860 selling confections and nuts. He partnered with another grocer, Gust F. Breckel, to open the Enterprise store by 1886. It sold china, glass, and queensware. (MM, gift of Richard F. Maier, 82.7.11.)

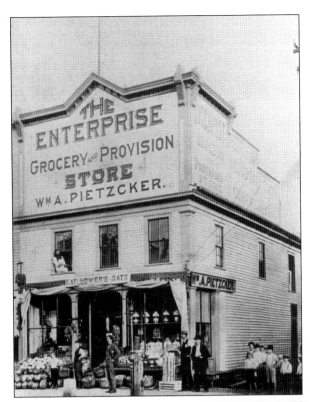

GUS WEIBLE'S GROCERY STORE, C. 1890. Few photographs show businesses north of Main Street. Weible's grocery store, which stood at 111 North Erie Street, was likely built in the 1830s and is seen in Fletcher's view of Massillon on page 62. Called the "White Mill," it appears on the far left of that photograph, along the canal. The Weible family is listed in the 1859 directory, but no further information about the grocery store has been found. The building was razed in 1910. (MM, gift of Helen A. Hardie, 99.33.2.)

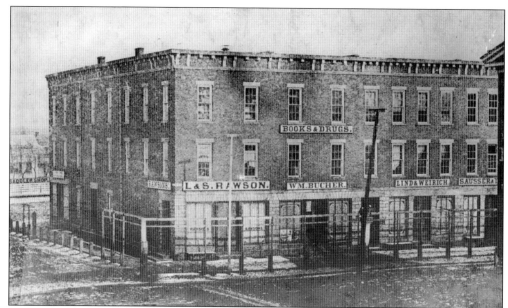

BUSINESS BLOCK ON THE NORTHEAST CORNER OF MAIN AND NORTH ERIE STREETS, C. 1853. After a fire destroyed the block on August 27, 1851, business investors rebuilt a similar block in the same location. Levi and Silas Rawson operated a dry goods store on the corner, William Bucher offered books and drugs, and Linda and Weirich and Sausser had other stores to the east. At the back of the block was a saddler shop. Small businesses or organization halls occupied the second and third stories. (Photograph by Abel Fletcher, Seaver Center.)

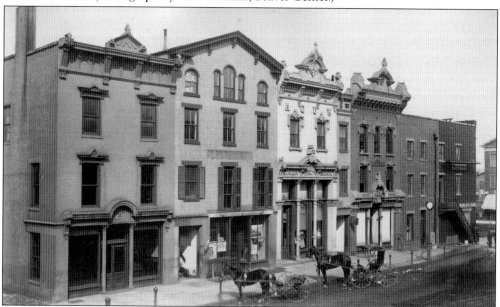

BUSINESSES ON THE WEST SIDE OF SOUTH ERIE STREET, C. 1860. The corner of Erie and Main Streets comprised the hub of Massillon commercial activities. Left to right: First National Bank, Abel Fletcher's photography studio, Union National Bank, the AOUW, Coleman's jewelry store (later Kirkpatrick's jewelry store, 1860–1891), and Oberlin Store (later Whitman's and Meinhart's). (MM, BC 2281.1a.)

BONAHAN CARRIAGE FACTORY, C. 1955. The Bonahan Carriage Factory was built about 1840 on the northwest corner of Plum Street and Mill Street Northeast. It also housed painter George Charles and blacksmith Sylvester Stump. The building was razed in the 1950s for the Massillon Savings and Loan Company. (MM, gift of the Karl Spuhler Estate, 91.7.3054.)

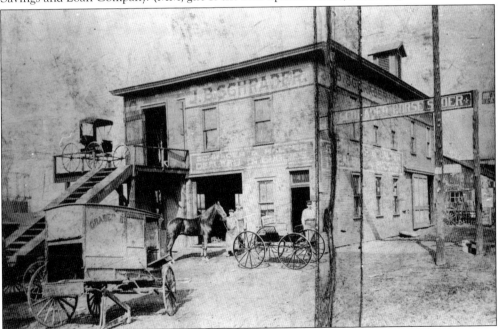

J.B. SCHRADER BUGGY SHOP, C. 1890. Blacksmiths were some of the earliest businesses in both Kendal and Massillon, and many citizens required shoes for their horses or wagon repairs. Joseph B. Schrader was a blacksmith in the 1880s near the corner of Hill and Main Streets. He added horseshoeing, forging, and carriage and wagon sales and repair. Pictured from left to right are John Crone, Amos McConnell, and Joseph B. Schrader. (MM, gift of the Karl Spuhler Estate, 91.7.1106.)

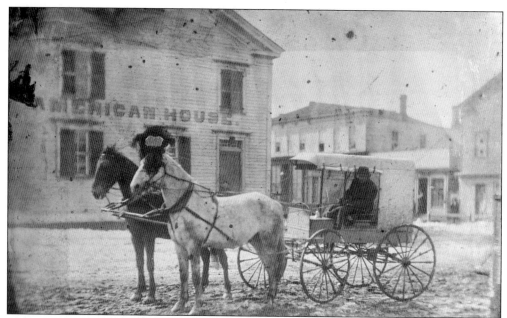

AMERICAN HOUSE, C. 1850. This tintype photograph shows the American House Hotel, located on the northeast corner of East Main and North Erie Streets, according to Henry Howe's 1848 sketch. The building burned in the 1851 fire that destroyed the entire block. (MM, gift of Harry and Mary McCroha Myers, 98.36.51.)

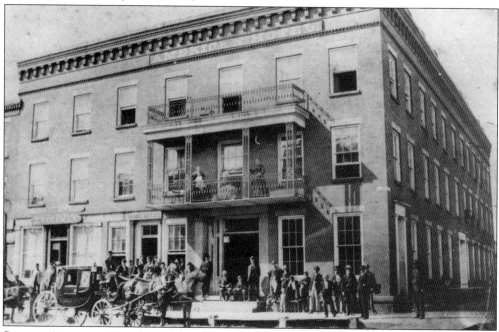

SECOND AMERICAN HOTEL C. 1860. After the first American House was lost to fire in 1851, businessmen Edward Upham, Samuel and George Hawk, Levi and Silas Rawson, and Dr. Joseph Watson rebuilt on the same location at the northwest corner of East Main and Mill Streets. It provided storefronts for the post office and Coleman's jewelry store at left. Later renamed the Conrad Hotel, it was also lost to fire, in 1983. (MM, gift of Ethel Conrad, 76.21.3.2.)

COL. THOMAS S. WEBB, 1832. Webb, a Quaker born on May 6, 1808, in Salem, Ohio, began as a saddler's apprentice. He opened the Franklin House in spring 1832, continuing as proprietor for 13 years. He was proprietor of hotels in Philadelphia, New York City, and Atlantic City. He achieved the rank of colonel in the state militia in 1836. His portrait was painted one year after he married Margaret Harbaugh. (Painting by David Baer, MM, gift of Mrs. M.A.W. Pratt, BC 237.)

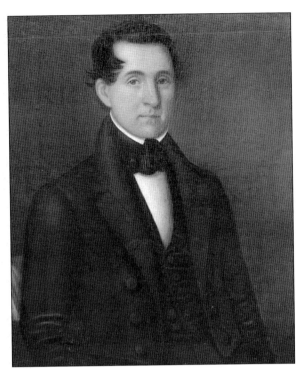

FRANKLIN HOUSE, C. 1845. Franklin House stood on Canal Street Southwest along the canal. In 1838, the Franklin Hotel hosted Whig candidate Gen. William Henry Harrison, the first to campaign for the office of president, and former president Andrew Jackson, who spoke in support of Harrison from the second-floor window. The hotel was later owned by H. Snyder, who turned it into a livery and stable. It was razed in 1921. (Paper negative photograph by Abel Fletcher, Seaver Center.)

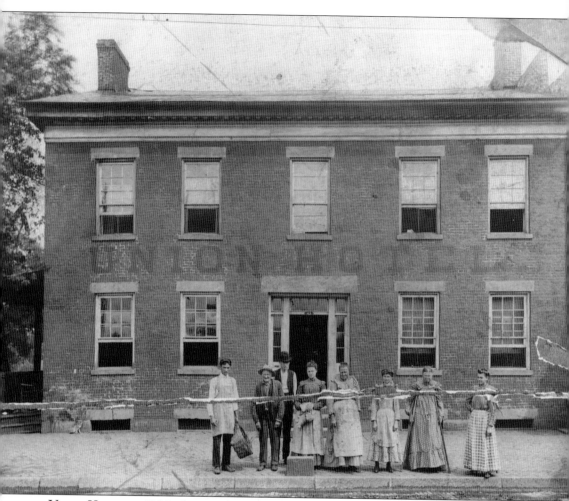

Union Hotel, c. 1890. Among those pictured here are Grandpa McGrath (second from left), Mary Leis (fourth from left), and possibly Lizzie Spuhler McGrath (seventh from left, on crutches). The Union Hotel was built in 1835 on West Main Street at the height of the canal era. The widow Lizzie Spuhler ran the hotel in the 1840s. Most guests were farmers who brought grain into town to ship on canal boats. The Port of Massillon had as many as 12 canal boats docked at a time, each with a crew of at least three, and sometimes the crew would all stay on land. The hotel accommodated between 50 and 60 patrons at a time. George McGrath married Lizzie Spuhler about 1850. Lizzie tended to guests and George cared for the stable. In 1840, presidential candidate William Henry Harrison returned to Massillon and stayed here. The hotel was razed in 1925 to make way for a gas station. (MM, 76.23.4.1.)

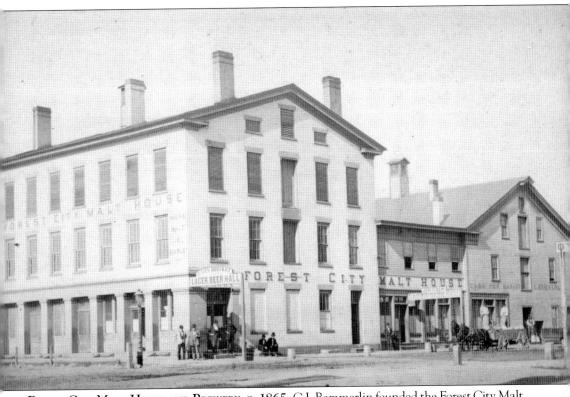

Forest City Malt House and Brewery, c. 1865. C.J. Bammerlin founded the Forest City Malt House, Brewery and Lager Beer Hall along the Ohio and Erie Canal on the northwest corner of Tremont Avenue and South Erie Street in 1842. The brewery had two cellars for beer—one on land that is now Lincoln Park near Seventeenth Street Northwest, and the other along the railroad tracks near Newman Creek west of town. Because the malt house used 30,000 bushels of grain per year, the Bammerlins had to buy barley from other parts of Ohio to meet its needs. In 1862, C.J.'s son Leonard Bammerlin took over. By that time, they brewed about 120 barrels of beer each month and sold cases of beer for $1. The business was lost to fire in 1882, and Leonard Bammerlin went into business manufacturing and selling cigars, candy, and cheese. (MM, gift of Fred Brucker, 56.133.3.)

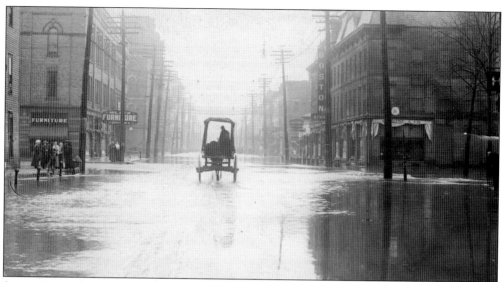

SOUTH ERIE STREET, LOOKING NORTH, C. 1910. Frank Warthorst constructed the Stone Block, at right, in the mid-1830s for the Massillon Rolling Mill Company. Each stone was expertly beveled so the building contains no mortar, one of only a few in the nation. By the 1870s it was called the Jarvis Block, named for its owner Kent Jarvis. The Stone Block still stands at the northeast corner of Tremont Avenue and South Erie Street. (MM, museum purchase, 72.66.1.7.)

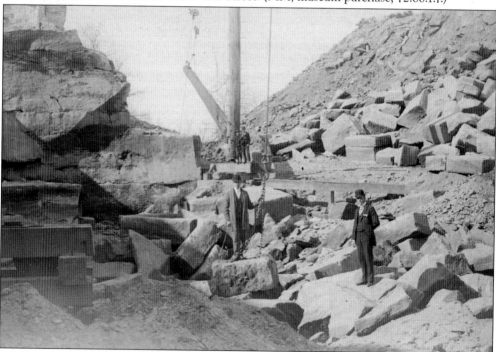

WARTHORST STONE QUARRY, C. 1890. Warthorst, an expert stone cutter and carpenter, was trained in his hometown of Bremen, Germany. The stones quarried here were beveled precisely to properly distribute weight. The quarry was located north of Massillon, west of the Tuscarawas River, and was later purchased by Suter and Everhard. Harry Croxton is holding chains in this photograph. (Photograph by George McCall; MM, BC 2319.5.4.)

STONE BLOCK EXTERIOR, C. 1920. Warthorst built the Stone Block with no mortar. The friction between horizontal joints holds the building together. It is impossible to insert a knife blade in the joints between the stones, which are one foot by three feet long. A gable roof was added later, but in 1876 Kent Jarvis replaced it with a Mansard roof. The building withstood the 1848 flood, except for one wall that was damaged. (Photograph by James Young, MM, BC 2314.18.)

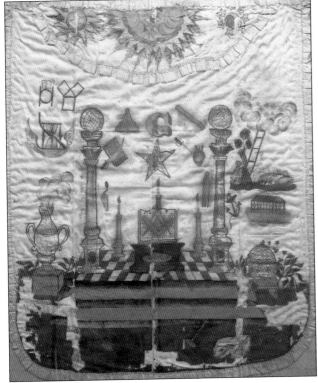

JEHIAL FOX'S MASONIC APRON, C. 1830. This Masonic apron was believed to belong to Jehial Fox, a member of the Friendly Association for Mutual Interests in Kendal. For decades, many knew the Stone Block as the Masonic Temple. (MM.)

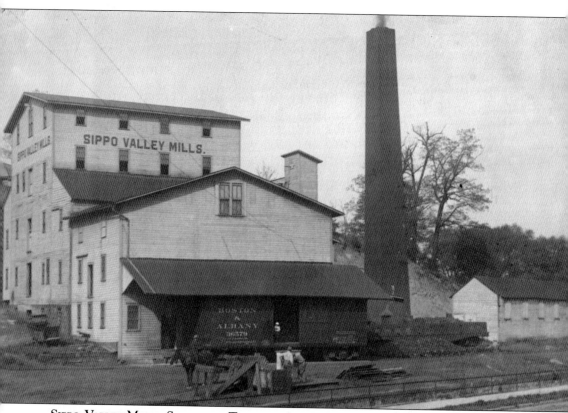

Sippo Valley Mills, Seen from Tremont Avenue, c. 1900. Later known as Warwick and Justus, the Sippo Valley Mills were built by Marshall Wellman in 1848 for $21,000. The business covered a large footprint on the hill between Tremont Avenue and Wellman Avenue Southeast. It originally used a 57-foot waterfall to run its two 26-foot-high waterwheels. The waterpower was sold to the city water company in 1876, and the mill was then powered by a Buckeye engine. By 1884, there were 17 employees who turned out 250 barrels of flour every day. The Sippo Creek ran in front of the mill, and the mill race ran through the mill. In the mid-1900s, Sippo Creek was channeled into a man-made underground culvert to the Tuscarawas River. Today, only the ruins of concrete supports of the mill are visible. (Photograph by Stanley Baltzly, MM, gift of Karl Spuhler Estate, 91.7.424.)

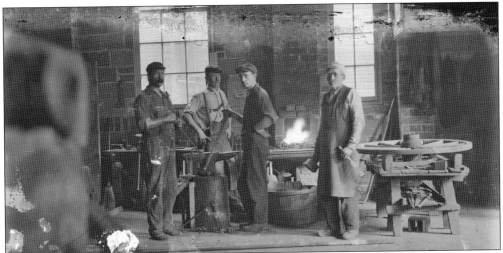

UNIDENTIFIED WAGON REPAIR SHOP, C. 1890. Transportation in early Massillon and Kendal involved horses and carriages. Horses needed horseshoes, and various wagon parts needed repairs. Two of the early businesses established in Kendal were blacksmith Jesse Otis and tanner Thomas Williams. This photograph illuminates the conditions in which blacksmiths worked. Blacksmiths, forgers, and horseshoers listed in the 1859 city directory include Noah Madison, John Menenger, Fred T. Pennywell, W.C. Richards, Henry Wagner, and William Zepp. (MM, gift of the Karl Spuhler Estate, 91.7.473.)

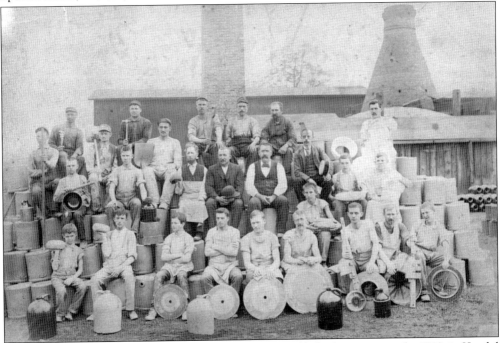

BOERNER POTTERY EMPLOYEES, 1890. Thomas Rotch established a pottery in the 1810s in Kendal near the Sippo Creek. In Massillon, Adam and William Welker oversaw the Massillon Pottery Company from 1860 to 1891. They produced vitreous china, fine earthenware, and stoneware. Here, employees of Boerner Pottery show off examples of their handiwork. (MM, gift of Homer Schrader, BC 2320.16.)

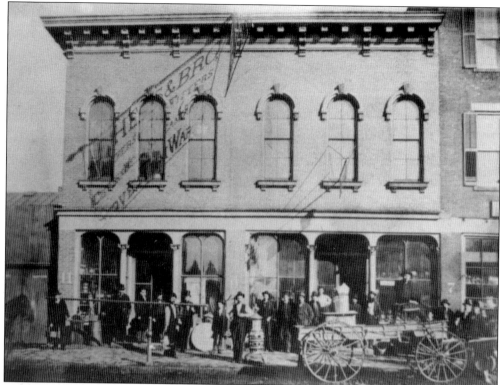

HESS BROTHERS, 1880. On the advice of his friend, John Sutter, Jacob Frederick Hess I (1834–1912) joined the Gold Rush in 1857 and returned with $2,500 in bullion. Hess founded J.F. Hess and Company in 1861 with his brother Leonard. Their first shop was located at 26–32 North Erie Street. The Hess brothers worked in the tinsmith trade, which involved plumbing, pipe-fitting, repairs, and patents for parlor heating stoves, furnaces, windmills, and downspouts. They employed The Russell & Company machinist Jacob F. Snyder, and the Hess-Snyder and Company was formed in 1882. (MM.)

VALLEY HOUSE AND STANDPIPE, 1898. Massillon Furnace, later the Valley House, produced plows, plow points, and kettles. It was established in 1833 in the Sippo Valley on Main Street. According to Sam Mauger, there were piles of charcoal, which his father, Jacob, stole to power his homemade automobile in 1853. The mayor, Squire Warner, said he would arrest Jacob Mauger because the sound it made scared the horses. (MM, gift of the Karl Spuhler Estate, 91.7.2800.)

Six
Washington's Birthday Flood of 1848

Under the leadership of James Duncan, the Massillon Rolling Mill Company purchased 1,100 acres of meadow along the Sippo Creek, today in the area of Sippo Lake. Surveys began in 1836, swamp land was drained, and a dam was built in 1844. It stretched 300 feet across Sippo Creek along today's Jackson Avenue/Twenty-seventh Street. Because the dam was 30 feet thick on the bottom with woven planks to form a six-foot-wide top, the water was held back almost two miles, forming a lake one mile wide and 15 to 20 feet deep, covering approximately 900 acres.

The dam was intended to provide drinking water, water to supply the canal, and power for the mills during the dry season. As the lake stagnated, nearby residents complained of the smell and appearance and claimed mosquitoes were spreading disease. At town hall–style meetings in Bahney's tavern in Genoa, they discussed remedies. Company officials ignored their complaints, stating that sicknesses were occurring all over, not just near the reservoir. Several residents petitioned the state to remove the dam. The state refused, stating that the dam was a great resource and served the purposes for which it was built; but it appointed a committee to investigate the claims of reservoir-induced disease. Citizens believed the state moved too slowly, so they took action themselves.

At approximately 3:00 a.m. on February 23, 1848, saboteurs axed the pilings and the dam collapsed. A 10-foot-high wave traveled at approximately 100 miles an hour toward downtown Massillon, which was 90 feet lower than the reservoir.

On that devastating night, the Tremont House (also a Massillon Rolling Mill venture) celebrated its grand opening and President Washington's birthday. By 3:00 a.m., about 20 revelers were still dancing when the floodwaters surrounded the structure. Charles Skinner rode up to the door and shouted, "Hallo! The reservoir's broke! Flee for your lives!" Guests ran to Tremont Avenue on the north side and found themselves quickly in waist-deep water. Several warehouses were destroyed, the canal banks caved in, and the total damage was between $30,000 and $40,000, estimated at $1 million today. Luckily, no lives were lost during the disaster. While Martin Clark, Thomas Noble, Amasa Bailey Sr., and several others were arrested, no trial was held and no culprit was definitively determined.

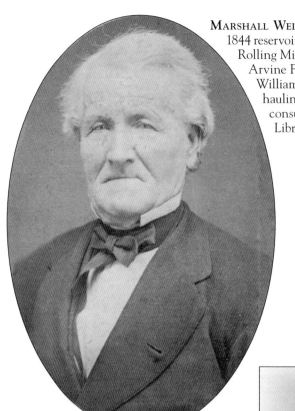

MARSHALL WELLMAN, C. 1860. Wellman oversaw the 1844 reservoir construction on behalf of the Massillon Rolling Mill Company. Local men William Keefer, Arvine Fox, Jacob Carper, Harmon Shriver, and William Tinkler were in charge of chopping and hauling trees from the land the reservoir would consume. (MM, gift of the Massillon Public Library, 83.39.196.)

TWO MEN ATOP A CANAL GATE, C. 1910. In the middle of the dam stood a keeper's lodge and mechanical controls. Much like the mechanical canal levers pictured here, the Massillon Rolling Mill Company reservoir dam had equipment to open various doors and alleviate water overflow if necessary. (Courtesy Cliff Lackey.)

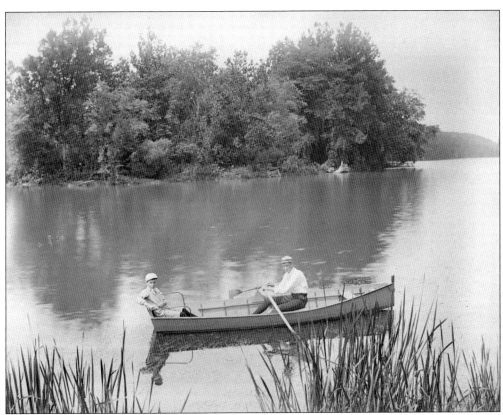

Two Men in a Boat, c. 1900. The reservoir created small islands on which many enjoyed picnics. In his 1847 diary, Arvine C. Wales "was invited by Charly Skinner and Stocking" to picnic at the reservoir with George Miller and James Bayliss. "The water stinks horridly. . . . We rode all over the reservoir and concluded that a large oak which spread its arms protectingly over a green spot on the largest island was the most fitting place for a picnic dinner." (MM, BC 2683.10.)

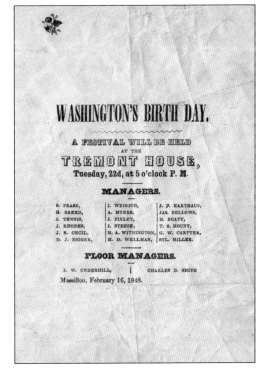

Tremont House's Washington's Birthday Invitation, 1848. This invitation was sent to many important and well-to-do patrons as far away as Cleveland, Ohio. This particular invitation was sent to Col. Thomas Webb, a local hotelier who ran the Franklin House. (MM, gift of Margaret Arline Webb Pratt and Mrs. W.K. Atwater, BC 2135.2.)

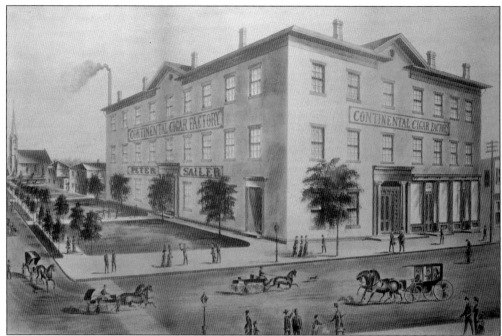

CONTINENTAL CIGAR FACTORY, 1887. The Tremont House (later the cigar factory) was a towering structure at the southeast corner of South Erie Street and Tremont Avenue. Musical entertainment for the grand opening was provided by W.A. McCauley's orchestra led by Sam Jones. The hotel's innovative spring floor in the ballroom provided a fine dancing surface. (Courtesy Rudy Turkal.)

SIPPO VALLEY NEAR MAIN STREET, LOOKING NORTH, C. 1890. Because of the dam, Sippo Creek was narrow and shallow. The floodwaters would have swept through the Sippo Valley along the creek, creating a much wider path as it flowed. The flood damaged properties along that path. (Photograph by A.J. Miller, MM, gift of Dan Douglass, 90.25.821.)

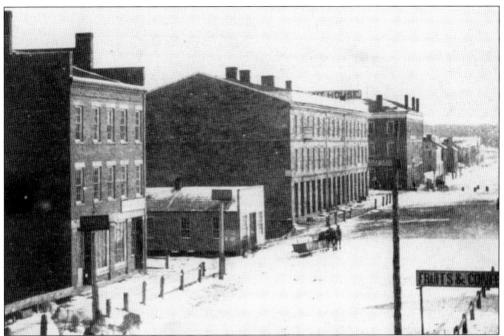

SOUTH ERIE STREET, C. 1850, AND FLOOD OF 1913. The rushing water of the broken Rolling Mill reservoir came careening down Tremont Avenue, slamming into Reynolds's warehouse, which likely sat just out of sight in the top photograph on the far right. The water was then diverted to the south wall of the Stone Block, which caused the wall to collapse. The torrent cut off the Tremont House and its guests with deep water. The solid gravel street was swept away, and a nine-foot chasm was cut into the road near the intersection of South Erie Street and Tremont Avenue, like the damage seen in the photograph below. Water filled the basements of every warehouse, destroyed walls, and crushed doors. (Above photograph by Abel Fletcher, Seaver Center; below, MM, gift of the Karl Spuhler Estate, 91.7.2249.)

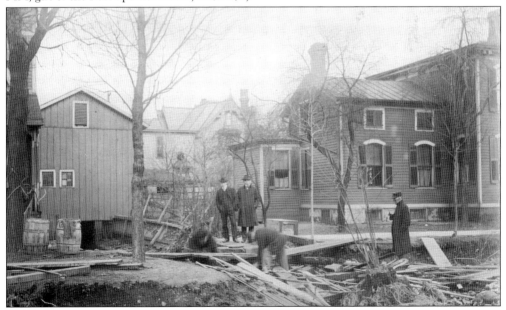

Looking West from Wellman Avenue, 1868. The two large buildings are the Tremont House (background center) and the Stone Block (background right). The homes in this area (foreground) were likely damaged when the floodwaters rushed through. The waterway (bottom right) is Sippo Creek, the path of the floodwaters. (MM, gift of the Karl Spuhler Estate, 91.7.2885.)

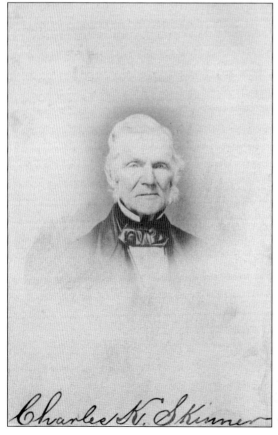

Charles K. Skinner, c. 1860. Was he the hero of the night? Some stories of the flood seem exaggerated. Skinner was described as Paul Revere, riding through the night to warn of the burst dam. How he was able to outride the 10-foot-tall, 100-mile-an-hour wall of water is unclear. Several primary source letters describe his warnings. Skinner might have had advanced knowledge of the saboteur's plans and warned people to prevent loss of life. Ironically, Skinner would suffer $2,500 damage to his woolen mill, confirmed by local experts in the business. (MM, gift of Betty Spidel Buchwalter, 68.23.13.11.)

Kent Jarvis, c. 1870, South Erie Street, 1854. Kent Jarvis's home sat along the canal, seen in the foreground of the painting below. Early on February 23, Charles Skinner rode past the Jarvis home and yelled warnings about the reservoir. Kent Jarvis wrote to his brother, "Of course we set about getting out the most valuable things from our house. It was dark, cold, raining, and aside from the disaster a very cheerless morning. And while engaged in removing our things, we could hear the unearthly roar of the flood, the cries of the people, the falling of buildings, but had no tidings where the flood raged most, who were in danger, what buildings were yielding to this mighty torrent." His daughter, Ann, was one of the remaining revelers at the Tremont House. The washed-out road led many to believe the hotel would fall. Jarvis managed to cross the floodwaters to the hotel, where he pulled the remaining patrons to safety. (MM, gift of Nancy Leffler, 07.44.17; painting by J.O. Osbourne, gift of the Edmund Pease Estate, BC 421.)

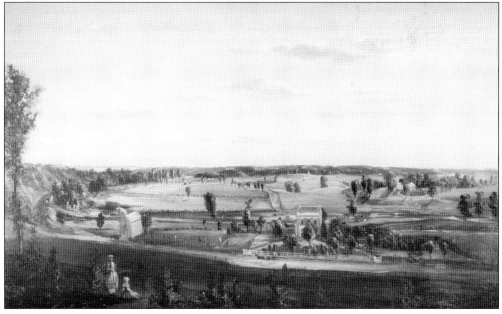

James L. Reynolds, c. 1860. Both James Duncan and his son-in-law Reynolds worked for the Massillon Rolling Mill Company. Flood forces cut between the Stone Block and the Tremont House, and hit Reynolds's warehouse, which brought walls down piecemeal. It was completely destroyed by floodwaters. The exact location is unknown, but judging by the flood's path, it would have been near the southwest corner of South Erie Street and Tremont Avenue. (MM, BC 2860.2.)

Joseph Watson and Company Groceries Wholesale Warehouse, c. 1845. The Dr. Joseph Watson family came to Massillon in 1822, wishing to be part of the "progressive age of canals," where communication was better with the outside world. Joseph Watson opened the first drugstore in town, also selling paints, oils, dyes, crockery, and glassware. Watson's warehouse was located on the south side of Main Street between Erie and Mill Streets and was one of the worst damaged in the 1848 flood. Joseph Watson's hogshead of sugar was found three miles away in Bridgeport. (Paper negative by Abel Fletcher, Seaver Center.)

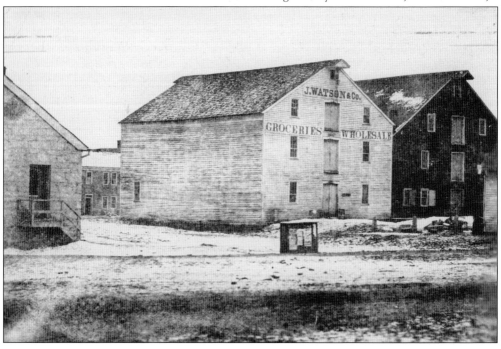

FENNER AND MCMILLAN ADVERTISEMENT, 1844. Fenner and McMillan began plastering these advertisements around town. They could offer great deals because prices were low at their large warehouse and dry goods store. Their store, located at 5 Erie Street, was one of the hardest hit warehouses along the Ohio and Erie Canal in the flood. They reportedly lost their entire inventory. (MM, gift of Albert Hise, 65.43.1.)

MARTIN AND VOGT GROCERY STORE, 1890. This grocery setup is similar to what Fenner and McMillan would have displayed in the 1840s. Martin and Vogt's store was located at the southwest corner of Main and South Erie Streets. (Photograph by A.J. Miller, MM, gift of the Karl Spuhler Estate, 91.7.481.)

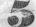

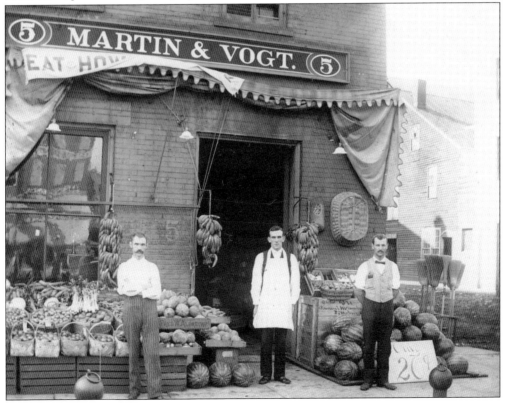

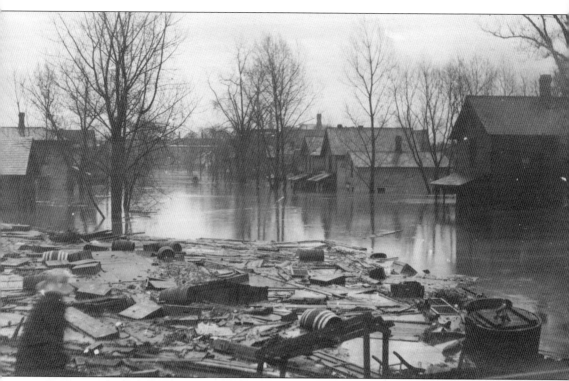

FLOOD DAMAGE, 1913. In a letter to his brother on March 14, 1848, Kent Jarvis describes the results of the February 22 flood. "The morning of the 23 February witnessed the execution of their threats in the horror—destruction—Misery, peril and distaff, which their wickedness flooded upon our ill-fated town." In his diary, Arvine Wales wrote that "the town presents a sickening spectacle of destruction and desolation." A February 1848 *Ohio Repository* article included this account: "We witnessed the scene of destruction on Saturday last and it is truly appalling. Never before have we believed that any quantity of water could have produced such destruction." Downtown streets became impassable the next day, littered with lumber, warehouse contents, mud, and canal boats. When the floodwater hit downtown, it broke the canal banks, emptied the canal, and carried canal boats into trees. Barrels of pork, cloverseed, flour, and other warehouse items were swept away out of their storage, many carried more than eight miles away. Barrels would be found years later near Zoar, Ohio, in the riverbed of the Tuscarawas River. (MM, gift of the Karl Spuhler Estate, 91.7.2211.)

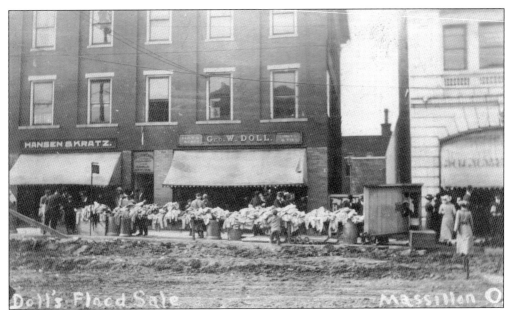

DOLL'S CLOTHING STORE, FLOOD SALE, 1913. Business owners faced massive losses in stock. As crowds gathered from all over Ohio to see the devastation, business owners had "flood sales" for damaged items. When the stock was sold out, other items were reportedly dipped in dirty canal water and sold as "the real thing." This photograph shows a similar flood sale after the 1913 flood-damaged stores, at 10 West Main Street. (MM, BC 2328.9.)

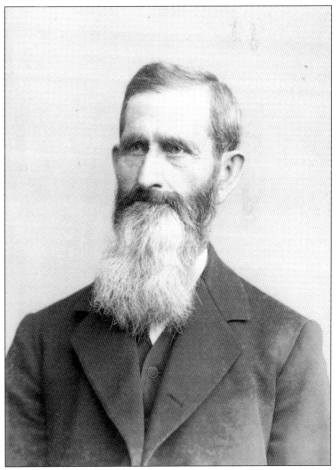

ARVINE FOX, C. 1876. Fox helped clear the swamp and trees on the reservoir property near his home. After the dam broke, he found a piece of support beam with ax marks lodged in an elm tree below the destroyed dam. (Photograph by J.C. Haring, MM, BC 2365.2.)

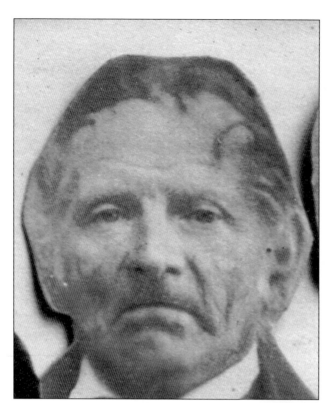

AMASA BAILEY SR., C. 1860. Amasa Bailey's farm was near the reservoir, and he was vocal about the sickness he believed it caused. He was arrested, along with Martin Clark and Thomas Noble, as a suspect of the dam's sabotage, but no official charges were ever filed. (Detail from collage photograph by Martha and Abel Fletcher, MM, gift of W.W. Pease, 76.39.3.)

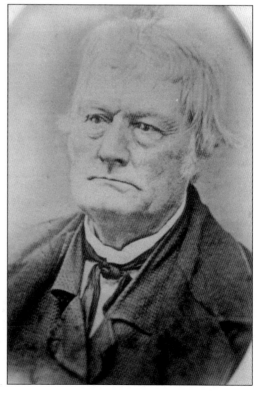

ARVINE WALES (1785–1854), C. 1850. For the dam sabotage, no trial was ever held and no definitive answers were ever revealed. According to his son, Arvine Wales had met with the alleged saboteurs about the legalities of the dam removal, but because of client confidentiality, he took the names of those responsible to his grave. (MM, BC 2304.15.3.)

Seven

Early Education

Public education in the early 1800s was not a guaranteed right as it is today. School classes were first held in residential homes. Subscription schools were often the only opportunity, a pay-to-play arrangement in which the teacher was paid based on how many students subscribed. If teachers were not already settled in the community, they would board with students' families on a rotating basis. Each new term gave them the chance to move on to a different town if they wished.

In Kendal, the "L" House community center provided school rooms. Terms were three months by private subscription and each student paid $1 to $1.50. Some of the best teachers were paid $200 per term.

In 1824, Charity Rotch's will dictated that a school be established, with the goal of teaching underprivileged children to become useful members of society. Boys studied agriculture, and girls learned housewifery, making it the first vocational school in Ohio. Trustees Arvine Wales, Mayhew Folger, Isaac Bowman, William Henry, and James Lathrop first served the school by special act of the Ohio Legislature.

Charity Rotch also bequeathed 150 volumes for a Kendal Social Library, established April 2, 1825. Members subscribed and met monthly. Books could be borrowed for two months, and members were fined 25¢ to $1 if they missed the meeting. Members expanded the library to 421 books of diverse subjects, housed on the upper floor of the Charity School house, until the library group disbanded in 1842. More than 70 volumes are preserved at the Massillon Museum.

In 1824 and 1825, the Ohio School Law gave communities the chance to elect a school board of directors and to pass a half-mill levy to pay for public school for part of the year. In 1827, Harlow Chapin of Washington County arrived and began teaching in James Duncan's former distillery at the corner of Mill and Charles Streets. Subscription continued until 1846 when a levy was passed for free public education in a Union School system. The school opened on lot 186, donated by Arvine Wales, James Duncan, and Charles Skinner. Wales also served on the first board of education.

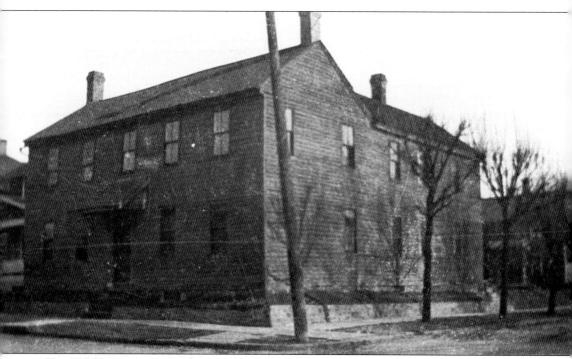

THE "L" HOUSE, C. 1910. This never-before-published photograph shows lot 84 at the southeast corner of Eleventh Street and State Avenue Northeast. The "L" House, named for its shape, boasted 75 panes of glass. It was built by Joshua Brandon in 1814 and purchased by Ephraim Chidester as a private residence in 1817. It also served as a school, Quaker meetinghouse, church, community center, grocery, and post office. *A Century of Education* by Mary Jane Richeimer lists William Mott, Cyrus Spink, Ruth Logue Galbraith, and Barak Michener of Canton as the first teachers in the community. Students recalled using one of the Kendal greens as a playground, and William Perrin remembered that Ruth Logue Galbraith's students all loved her. Captain Folger had limited education, and when his misspelling was pointed out by a teacher, Folger stated that spelling was not important. Another view of this building can be seen in the aerial photograph on page 21. (MM, gift of Karl Spuhler, 91.7.1717)

Eliza Reed Skinner (1797–1866), c. 1860. Eliza was born in 1797 in Lynn, Massachusetts, to Thomas and Elizabeth Phillips Reed. The family came to Kendal in 1817. Eliza Reed was one of the first teachers at the "L" House in Kendal. On November 23, 1821, she married Charles K. Skinner, a partner in the woolen mills of both Thomas Rotch and James Duncan. (MM, gift of Betty Spidel Buchwalter, 68.23.13.11.)

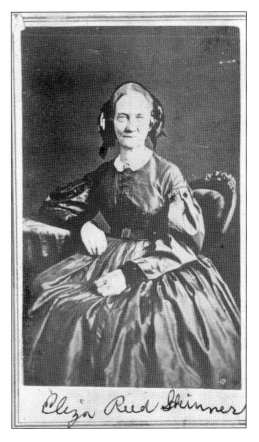

Page 13 of a Math Textbook by Barak Michener, c. 1817. During the early 1800s, there were no standard printed textbooks in a pioneer town, so teachers made their own. One of the early teachers, Barak Michener, created several textbooks for his students, whom he taught in the "L" House. (MM, gift of the Etta Michener estate, 57.70.32B.)

HARLOW CHAPIN, C. 1860. Chapin arrived in Massillon with little and asked to organize a school. No suitable building existed, and he met with resistance. John Everhard established the $12 per month salary. Jacob Miller provided board for Chapin. His first class met in the former James Duncan distillery that measured 20 square feet. Children sat on slab benches. Chapin was also a member of the Temperance Union. (MM, BC 2348.1.)

1855 PRIMARY SCHOOL, C. 1890. By 1854, the Union School was overcrowded and the Board of Education authorized the construction of a primary school building at the northeast corner of Tremont Avenue and East Street. The building, which cost $3,300, was 53 feet long and 33 feet wide. It was one story with a basement. By 1881, the school was obsolete and was sold to Augustus Skinner as a residence. (Photograph by Robert Peet Skinner, MM, gift of the Massillon Public Library, 84.33.3.)

CHARITY SCHOOL OF KENDAL, 1910. Charity Rotch wanted to help educate the underprivileged children in the area. Through sale of wool from her own flock of sheep, she started a fund to establish a school as part of her will. Classes began in the top floor of the springhouse on Spring Hill Farm in 1829, five years after her death. It was not until 1844 that the Charity School of Kendal building was constructed. (MM, BC 2295.2)

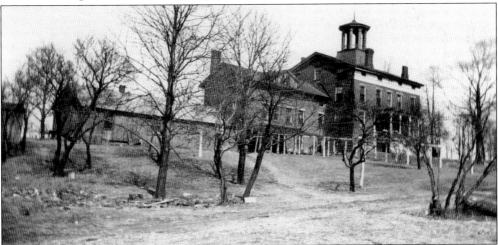

CHARITY SCHOOL OF KENDAL BUILDING AND ORCHARD, 1910. The school's orchard was part of expansive grounds. The Charity School was the first vocational school in Ohio, teaching farming to boys and housewifery to girls. The school closed in 1910 and was razed in 1926. Today, the Charity School of Kendal Foundation still assists underprivileged students with vocational scholarships each year. (MM, BC 2295.7)

MARY WATERMAN INDENTURE, 1857. As Charity School's popularity grew, classroom space became crowded and funding restrictive, and the application process became competitive. Applications required students and their parents or guardians to prove inability to pay for school; that their parents were dead, incarcerated, or morally depraved; or that the student had been abandoned. Accepted students, who became wards of the school until they reached the age of 18, were required to sign indenture contracts like the one at left. (MM, gift of Mrs. Fred Gates estate, 85.70.63)

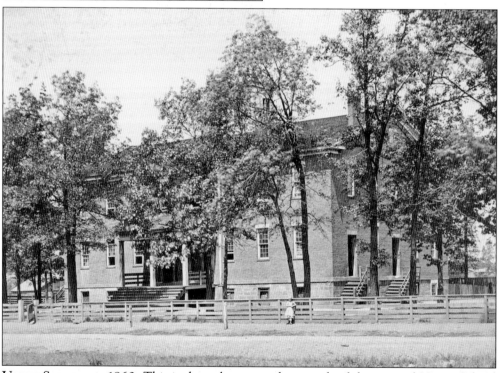

UNION SCHOOL, C. 1860. This is the only extant photograph of the original Union School building. A lithograph sketch of the school adorned diplomas for decades. The school stood 60 feet by 90, had two stories and a basement, where the janitor was given living space for his family. Two double backhouses were 25 feet in length and six feet in width. The school board paid businessman Henry Yessler $5,740 to build the school, including $500 for lumber alone. (MM, BC 2296.23a.)

LORIN ANDREWS (1819–1861), C. 1845. Andrews served as Union School's first superintendent between 1848 and 1851 with a salary of $800. In her 1890s memoir, Mary Jarvis Fay describes Andrews as "the beloved and efficient principal." Andrews served as president of Kenyon College from 1854 to 1861 and was the first Ohioan to enlist in the Union army in 1861 during the Civil War. He died of typhoid fever within the first year of the war. (MM, BC 2304.2.3.a.)

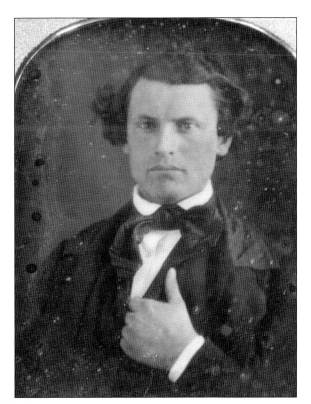

DR. THOMAS WADLEIGH HARVEY, C. 1860. Harvey came to Ohio in 1833 and received his teaching certificate in 1841. After Andrews resigned as superintendent, Harvey served from 1851 to 1865. Each night, he worked on his reader and grammar books. Like *McGuffey's Readers*, Harvey's books were used in Massillon schools for decades. He left Massillon in 1865 to serve schools in Painesville, Ohio, and later became the state commissioner of schools. (Photograph by Martha Fletcher, MM, BC 2304.1C.)

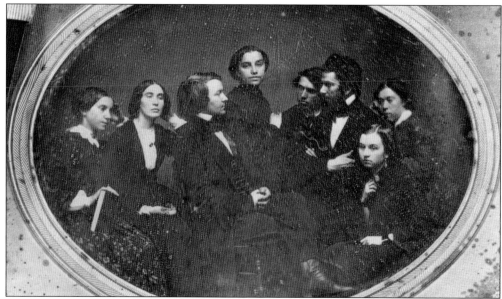

SUPT. THOMAS HARVEY AND UNION SCHOOL STAFF, 1851. Sarah Hoxworth began teaching for a salary of $140. She taught more than 23 years in the same Union School building. Pictured from left to right are Nancy Alban Stone, Jane Becket Martin, Thomas Harvey, Sarah Hoxworth, "Herr" Frederick W. Leoffler, grammar teacher Charles Shreve, Sarah C. Pearce, and primary teacher Mary A. Russell. (Daguerreotype photograph by Abel Fletcher, MM, gift of Miss Lillian Fletcher, BC 2304.7.)

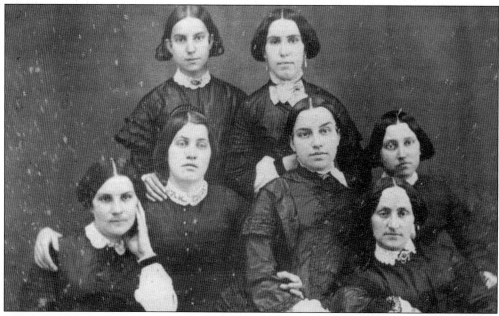

MASSILLON UNION SCHOOL TEACHERS, C. 1848. Pictured from left to right are (seated) Nancy Alban Stone, Miss Turner, Sarah Hoxworth, Jane Becket Martin, and H. Bradshaw; (standing) Ruth Hurlburt (later Mrs. B.F. Seaton) and Selina Jarvis. Enrollment for the first quarter was 481 total students. In the high school, enrollment was 60 students, with average attendance of 46. (Daguerreotype photograph by Abel Fletcher, MM, BC 2304.6.)

Eight

RELIGION

Religion arrived with the first settlers of the Ohio frontier. Methodists began meeting in this area in 1810, and by 1816 a circuit preacher visited monthly. When Thomas Rotch established Kendal in 1812, many of the first residents were Quakers. Friends met in homes, community centers, and Quaker meetinghouses. Thomas and Charity Rotch both attended monthly and yearly meetings in this region and served as church leaders. A Lutheran congregation formed Holy Trinity Lutheran in 1826 in the village later called West Brookfield.

James Duncan helped to form St. Timothy's Episcopal Church in 1834 and set aside Massillon Rolling Mill land to build a church in 1836. Duncan hosted the first Episcopal wedding in his home. The first Baptist preachers arrived by canal about 1838, but they did not organize a congregation until 1899.

Presbyterians first met in Daniel Myers's carpenter shop in Kendal in 1829, but the congregation dissolved in 1848 and reorganized in 1851. Samuel Pease, Massillon's first mayor, was one of the first trustees of the Second Presbyterian Church. The Wales family rented a pew in the first church.

The German and Irish Catholics bought the property for St. Mary Roman Catholic Church and founded their parish in 1839. Their 1842 building was destroyed by fire in 1852, possibly by arson. When discussing a new building, the Germans and Irish could not agree on a plan, and the Irish Catholics founded their own St. Joseph's Church in 1854.

Other churches, not depicted by photographs, established in early Massillon were Epworth United Methodist Church (1811), St. Paul's Lutheran Church (1864), and St. Barbara's Catholic Church (1866).

DANIEL MYERS CARPENTER SHOP AND PRESBYTERIAN CHURCH, 1926. Presbyterians began worship services in 1829 in Daniel Myers's carpenter shop on State Street. By 1831, the congregation grew too large for the small shop, and it erected a building between Massillon and Kendal. Presbyterians were the third religious group to hold services in Kendal, after the Methodists (1810) and the Quakers (1811). (MM, gift of Karl Spuhler Estate, 91.7.636.)

ST. TIMOTHY'S EPISCOPAL CHURCH, C. 1890. The Episcopal congregation was formed in 1834. Before the parish had a building, James Duncan hosted the first recorded Episcopal church service in Massillon at his home. After building delays, the church began construction in 1836 and completed the building in 1843. In 1892, the sandstone started to crumble; a new building was consecrated in 1899 at the same site on the southeast corner of East Street and Tremont Avenue Southeast. (Photograph by J.C. Haring, MM, gift of Mrs. L. Shauf, BC 2292.2.2.)

SILAS AND AUGUSTA HURXTHAL RAWSON, c. 1860. St. Timothy's Church was merely a basement when the first wedding was performed. Rev. John Swan performed a double marriage on June 2, 1840, when Isaac H. Brown married Elizabeth J. Wheeler, and Silas A. Rawson married Augusta Hurxthal. Rawson owned a dry goods store with his brother Levi on the northeast corner of Main Street and Erie Street. (Both MM, BC 995.)

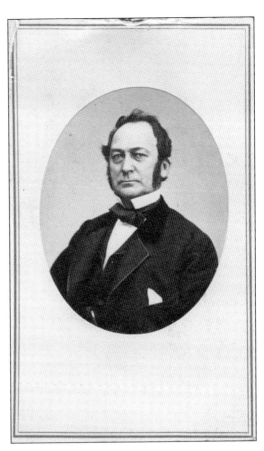

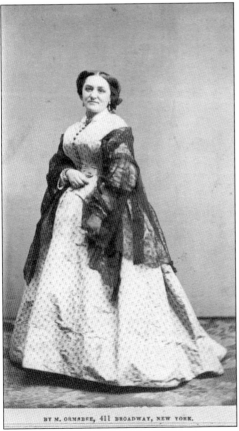

FIRST CHRISTIAN CHURCH, C. 1920. The First Christian Church held its first services in the Doxsee home, at the southeast corner of Main and Factory Streets, in 1843. In 1846, the congregation moved to this building near the corner of North Avenue and Hill Street Northeast. The building is a private residence today. (MM, BC 2284.34.)

ST. MARY ROMAN CATHOLIC CHURCH, C. 1865. German and Irish immigrants founded the parish of Neue Katholische Mutter Gottes Kirche (The Catholic Church of St. Mary, Mother of God) in 1839. After the 1852 fire, construction on its second building, a grand rendering of which is seen here, began in the 1860s. The first St. Mary school was held in the basement in 1849. The Gothic-style church is 185 feet in length and 85 feet wide, with a 95-foot tall vaulted ceiling. Sandstone for the building was quarried by Frank Warthorst. (Architectural rendering by Leon Beaver, MM, gift of Mr. and Mrs. Edward Gogel, BC 160.)

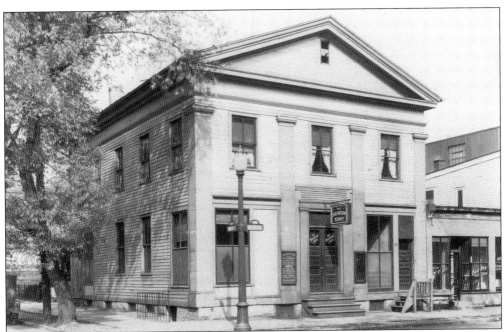

METHODIST CHURCH AND MASON HALL, C. 1900. Methodists met in an abandoned brewery on North Erie Street in 1831. By 1840, they joined with the Masons to erect this two-story frame building, which sat on the east side of Mill Street next to Duncan's mill, and was later moved to the west side of the street. (MM, BC 2315.)

HOLY TRINITY LUTHERAN CHURCH, C. 1910. Founded in 1826, the first congregation of Holy Trinity Lutheran Church met in a log cabin on Newman Road. Then it moved into this West Brookfield schoolhouse. After a decade of worshipping here, members built a red brick building at the far western edge of the settlement on the old State Road. (MM, gift of the Karl Spuhler Estate, 91.7.590.)

ST. JOHN UNITED CHURCH OF CHRIST, FIRST BUILDING, C. 1950. The German Evangelical Church organized St. John's in 1837 to cater to the growing local German population. Parishioners first met in this existing stone structure, once located south of St. Timothy's on the southwest corner of Oak and East Streets Southeast. The congregation moved to its current location in 1864 and sold this building to the school board. The building was later known as the Old Stone School. (MM, gift of Lois McAllister, Ralph Cornell Estate, 07.45.117.)

ST. JOHN'S LUTHERAN CHURCH AND PRESBYTERIAN CHAPEL, C. 1940. When the Presbyterian congregation grew too large for Daniel Myers's carpenter shop, it erected this building in a wooded area between Massillon and Kendal in 1831. Built in the 19th-century carpenter's Gothic style, this building later served the St. John's Lutheran congregation. (MM, gift of Lois McAllister, Ralph Cornell Estate, 07.45.117.)

Nine
LIFE IN MASSILLON

In 1811, William Henry opened a sawmill on the Little Sippo Creek, west of the Tuscarawas River. Because the creek's waterflow was insufficient, Henry used steam power, the first of its kind in Stark County. Thomas Rotch purchased oak and poplar boards from Henry's mill to make his woolen mill in Kendal. Henry was elected an Ohio State representative in the 13th General Assembly and was elected associate judge in the Stark County Common Pleas Court for seven years. Thereafter, he was called Judge Henry.

Henry lost major business opportunities when James Duncan won the bid for the Ohio and Erie Canal contract, placing it on the Tuscarawas River's east side through Massillon. Henry wisely invested in both Massillon and Kendal, opening dry goods stores in both, and had his own tanneries, cider mill, and woolen manufactory. He founded West Massillon in 1831 and West Brookfield in 1835. The success of Massillon eclipsed any financial gain he hoped to make with his new villages. Competition with Massillon and Kendal left Henry tired and unsuccessful, and he retired to Wooster.

Massillon was incorporated as a town in 1838, but costly ventures sank the town into debt. In 1845, property owners signed a petition to repeal the incorporation. In 1853, Massillon was again incorporated, this time including Kendal and West Massillon. By this time, the population was 4,000, which was the last time Massillon claimed a larger population than Canton, the seat of Stark County. There were fruitless discussions about moving the county seat to Massillon.

Because of the extensive downtown fire in 1851 and the St. Mary Church arson in 1852, the first city contract was with Charles K. Skinner's Massillon Water Company to provide water for the purpose of extinguishing fires. The company built a reservoir on Wellman Avenue, between Prospect and Plum Streets. Pipes carried the water into town.

The first city ordinances included an eight-mile-per-hour speed limit that carried a fine between $1 and $20, prohibition of intoxication in homes and businesses, and the prohibition of indecent exposure during daylight hours.

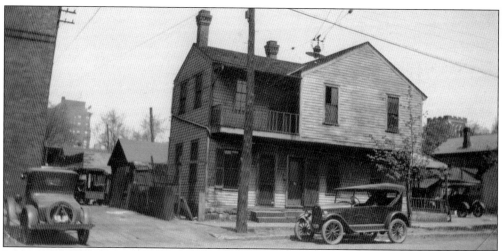

JULIUS HEYDON'S FARMER'S HOTEL, C. 1926. This is the only known photograph of Julius Heydon's home, the first built in Massillon. Through the years, many additions were built to turn the residence into the Farmer's Hotel. Massillon's *Weekly American* newspaper noted that the Farmer's Hotel offered wholesome food and good stables. (Photograph by Albert Hise, MM, gift of Albert Hise, BC 2284.2.)

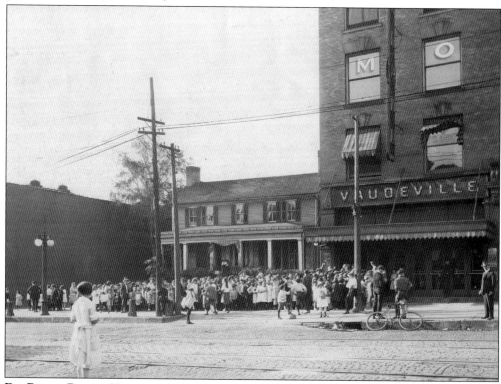

DR. BERIAH BROOKS HOME, C. 1920. The second house in Massillon, built by physician Dr. Beriah Brooks, formerly of Kendal, stood one door east of the northeast corner of Main Street and Mill Street Northeast. Brooks and his wife died in the home before 1837, and it sold to George Breed, to Otis Madison, and in 1858 to John Conrad. It was later occupied by Ohio state representative S.A. Conrad. (MM, BC 2280.1)

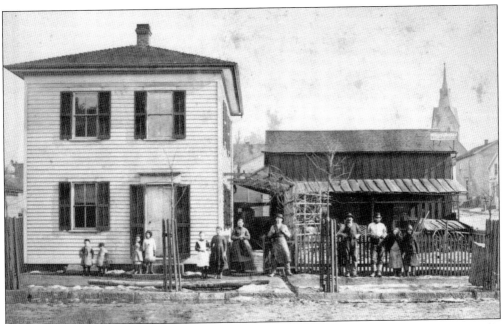

GEORGE REES WAGON SHOP AND HOME, C. 1870. Many Massillon residents found it fiscally achievable to have their business and residence in the same building or on the same property. The Rees family conducted business from their home on the corner of Plum and Mill Streets, across from the Bonahan Carriage Factory. Pictured are George and Eva Rees, and several employees and family members. (MM.)

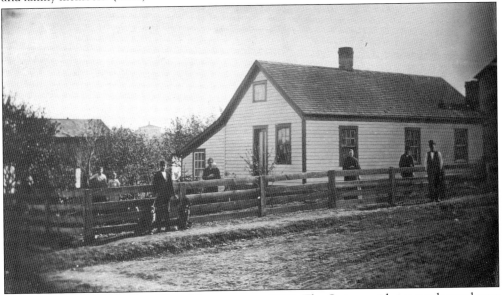

STEWART QUINN RESIDENCE, WEST MASSILLON, C. 1880. The Quinn residence was located near the intersection of Henry Street Southwest and West Main Street. Saltbox-style homes, which resembled the early 1800s box where salt was stored, were popular in this area. Many original Kendal homes were built as saltboxes, which allowed additions to be readily constructed. In this photograph, there is a clear break between the original rectangular house and the sloping roof over the addition. (Photograph by Theodore C. Teeple, MM, gift of Walter Shafrath, 57.183.1b7.)

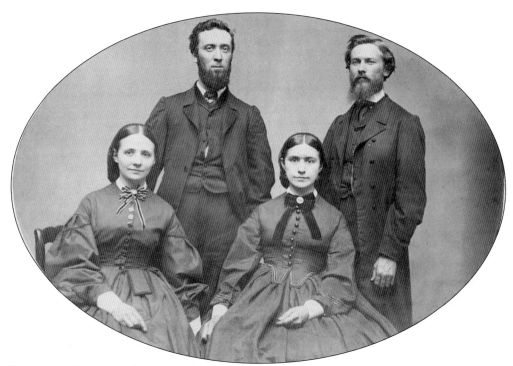

PETER AND ELIZABETH STAHL ALBRIGHT, ALEXANDER AND CHRISTENA STAHL GARVER, 1867. Peter Albright (1838–1895) ran a wholesale grocery store in Massillon on Main Street opposite the American House in 1860, was a Freemason with Sippo Lodge 47, and was a business partner with J. Walter McClymonds in the German Deposit Bank. In 1865, he married Elizabeth Stahl (1840–1887), the daughter of Andrew Stahl, a German immigrant and successful innkeeper in Navarre, Ohio. Elizabeth's sister Christena (1842–1902) married Alexander Garver (1839–1922), a successful druggist in Navarre. They had three children. (MM, gift of Harriet H. Grossnicklaus, 61.57.1.)

ELIZABETH ETTLEMAN MILLER (1788–1854), c. 1850. On February 9, 1814, Ettleman married Jacob Miller (1792–1843), an associate county judge. The Millers provided boarding for Harlow Chapin, the first schoolteacher in Massillon. Jacob Miller built a hotel on the southwest corner of Main and Mill Streets in 1827 that was lost to fire in 1853. Their descendant, Frank Lee Baldwin, a prominent lawyer, lived in James Duncan's former home on the northeast corner of Hill and Main Streets, which he and his wife bequeathed to the community. (MM, gift of Mrs. Blanche Neville, 61.131.)

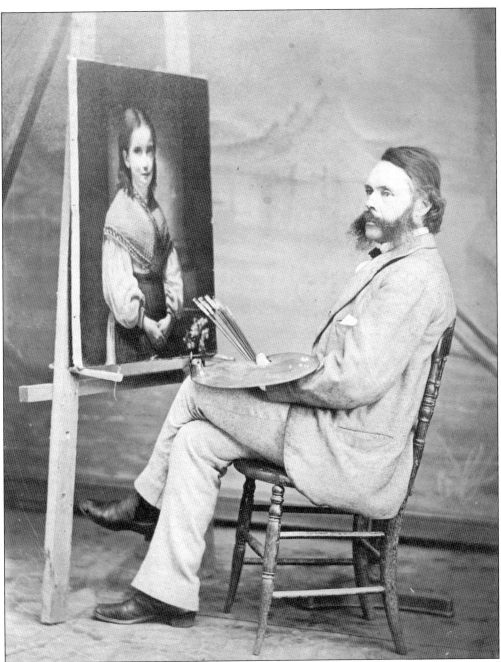

WILLIAM T. MATHEWS (1821–1905), C. 1860. Born in Bristol, England, William T. Mathews and his family moved to Navarre, Ohio, just south of Massillon, when he was a young boy. Mathews was commissioned to paint many prominent Massillonians and earned the moniker "Painter of Presidents" for his commissions to paint five American presidents. An 1848 letter from Horatio Watson to Arvine C. Wales reads, "Mr. Mathews is in town, but will leave for New York in a few days, where he intends spending the winter in improving himself in his art. He is getting up a lottery to dispose of his pictures, as he is rather short of funds." For historians, his portraits provide the only visual evidence of some Massillon residents. (MM, gift of Albert Hise, 79.14.1.)

SAMUEL BEATTY, C. 1845. The Republic of Texas revolted against Mexico in 1836, and in 1845 the United States annexed Texas. Mexico, which considered Texas to be its territory, declared war. Maj. Gen. Zachary Taylor and US troops went in to defend the new state. In 1848, Mexico eventually accepted surrender and gave up territories of New Mexico, Northern California, and Texas to the United States. The Mexican War created veterans who later led American Civil War armies during the 1860s, including Samuel Beatty, who became a major general in the Union army, the highest ranking officer from Stark County. (Daguerreotype attributed to Abel Fletcher, MM, Museum purchase, 61.145.)

GEN. DWIGHT JARVIS (SR., THE ELDER, 1797–1863). Jarvis served as major general in the Sixth Ohio Militia and recruited soldiers for the Mexican War. He was a member of the board at the Military Academy at West Point and a friend of Robert E. Lee, commander of the Army of Northern Virginia during the Civil War. Jarvis was instrumental in securing schooling at West Point for his nephew Dwight Jarvis (Jr., the younger, 1836–1904). (MM, gift of Louis Hurxthal, BC 2548.)

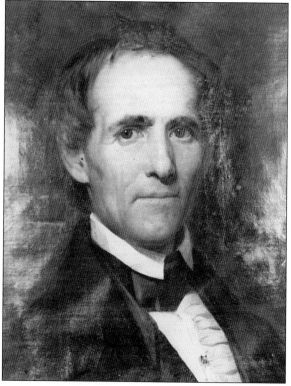

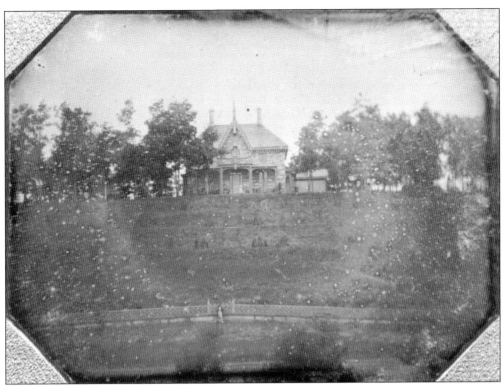

DWIGHT JARVIS HOME "BELMONT," C. 1850, AND FRANCES UPHAM JARVIS, C. 1865. Dwight Jarvis Sr. built his Gothic Revival home in 1850 at 1304 South Erie Street, across from "Edgewater," the home of his brother Kent Jarvis. He lived there with his wife, Frances Upham Jarvis, niece of James Duncan. They had no children, but they welcomed their niece Mary Jarvis, who lived there for 14 years while she taught music and various school subjects. Massillonians recalled leisurely walks along South Erie Street to see the scenic cemetery and the Belmont house with its terraces and fountains. The house was so grand for its time that it was memorialized in an etching in the *1876 Stark County Atlas*. The home was sold after their deaths and eventually razed in 1948. (Both, MM, 83.10.2, and gift of Mrs. Fred Ryder, BC 2272.1)

BROWN CHILDREN, C. 1851. Posing for a photograph was a major event for a family. Exposure times were typically more than 15 seconds, making photographing small, active children very difficult. Here, the four children of James Monroe and Mary Emmeline Hicks Brown behaved long enough for a large daguerreotype to be taken. From left to right are Mary Lucinda, twins Huntington and Hicks, and J. Ephraim Brown. (Attributed to Abel Fletcher, MM, gift of Miss Mary H. Merrick, 67.42.6.)

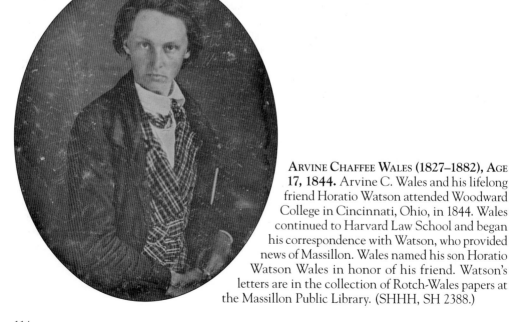

ARVINE CHAFFEE WALES (1827–1882), AGE 17, 1844. Arvine C. Wales and his lifelong friend Horatio Watson attended Woodward College in Cincinnati, Ohio, in 1844. Wales continued to Harvard Law School and began his correspondence with Watson, who provided news of Massillon. Wales named his son Horatio Watson Wales in honor of his friend. Watson's letters are in the collection of Rotch-Wales papers at the Massillon Public Library. (SHHH, SH 2388.)

HORATIO WATSON, C. 1845. Horatio Watson worked in his father's grocery and dry goods store. He also had a taste for adventure. In a letter to friend Arvine C. Wales, he wrote, "The idea of going to the shores of the Pacific had been one of my favorite day dreams for many years, but I never had any expectation of really going there . . . until the gold news from California." Watson set out in early 1849 by ship in New York, crossing Mexico by mule, horse, carriage, and foot. His letter alludes to fights with bandits and robbers along the road. Historical accounts state that Watson was never heard from again after his 1849 letter about bandits. Reexamination of his letters to Arvine C. Wales and genealogical records reveal that Watson arrived and set up a very successful mining business, evidenced in a letter to Wales in 1858. (MM, gift of Mrs. Horatio Wales 63.163.)

Dr. Joseph Watson Home on Prospect Street, c. 1870. Many boarders lived at the Watson home, including several laborers from Germany. The Watson home was moved to Eleventh Street in 1891 to make way for the grand Five Oaks mansion of the McClymonds family. (MM.)

Marshall Wellman Family Home, c. 1890. Marshall Wellman, of the Wellman-Atwater canal warehouse success, built his home on Main Street in 1838. It was reportedly a stop on the Underground Railroad. Flora Wellman London, mother of author Jack London, was born here in 1843. The home was sold to his brother's Volcano Iron Company business partner, Judge James S. Kelley, in the 1860s, and razed in 1954. Pictured is driver Fred Stryker. (Photograph by Volkmor, MM, gift of Ted Doll and A. Dale Fasnacht, 2013.004.15.)

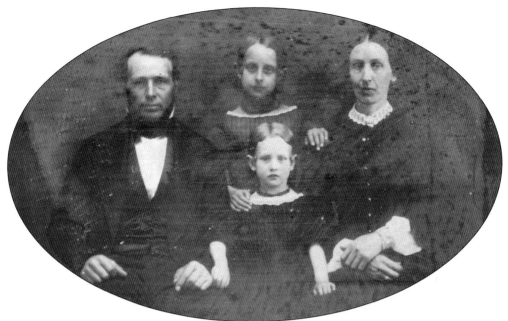

NAHUM RUSSELL FAMILY, C. 1851. Nahum Russell was one of the seven Russell brothers of The Russell & Company. His family purchased this extravagant portrait, which is encased in a thick, inlaid pearl and gold leaf mock book Bijou case, which clasped together and could be hidden amongst books on a shelf. Pictured from left to right are Nahum Russell, daughters Mary (nicknamed Mai) (standing) and Flora (front), and wife Esther Kellogg Russell. (MM, gift of Lea Frey.)

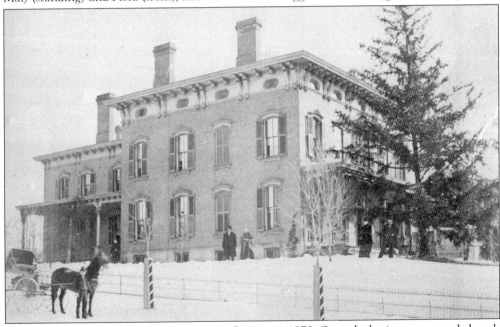

NAHUM RUSSELL FAMILY HOME ON PROSPECT STREET, C. 1870. Once the businesses succeeded, each of the Russell brothers built a grand home in Massillon. Constructed about 1860, this home was donated to the community by the Russell daughters, Flora Russell McClymonds and Annie Russell McClymonds, to house the McClymonds Public Library in 1899. (MM, gift of Lea Frey.)

OLD DOUBLE HOUSE IN SMOKY HOLLOW, WEST OAK STREET, C. 1930. Early duplexes provided an affordable way to have spacious living quarters for a family. The Edwin Jarvis family shared a double house with the Anson Pease family in the 1850s before each family built its own grand home after business success. (Photograph by James Young; MM, BC 2284.31.)

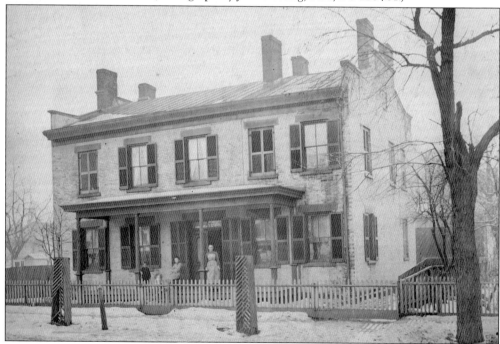

JACOB FREDERICK HESS I HOME, 77 PLUM STREET, C. 1880. The Hess family arrived in Massillon in the 1850s from Kandern, Baden, Germany, near the Swiss border. Hess brothers Jacob and Leonard, tinsmiths at Partridge and Company, later founded their own company in 1861. Pictured from left to right are Albert, Emma, and Tille Hess. (MM, museum purchase, 71.70.10.)

DR. ABRAHAM METZ, C. 1865. Veteran of the Mexican War and eye surgeon Dr. Abraham Metz wrote *Anatomy and Histology of the Eye*, which was used in colleges. His fame spread, and people from across the country sought his expertise. He founded Charity Hospital Medical College (now part of the College of Wooster). He developed a method for cataract surgery. (Photograph by J.F. Ryder of Cleveland, MM, Miss Estaine Depeltquestangue, BC 2110.20.)

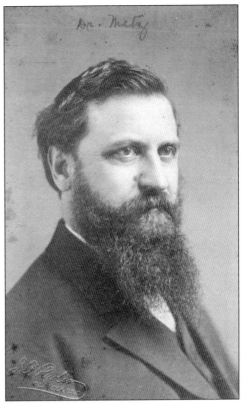

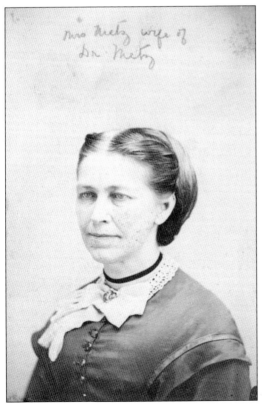

ELIZABETH PATTERSON METZ, C. 1860. Dr. Abraham Metz's wife, Elizabeth, had this portrait first taken as an ambrotype. For decades, she remained unidentified until this photograph was discovered with her name. In addition to raising their daughter, Ada, Metz was involved with church affairs. (Photograph by Martha Fletcher, MM, Miss Estaine Depeltquestangue, BC 2110.21.)

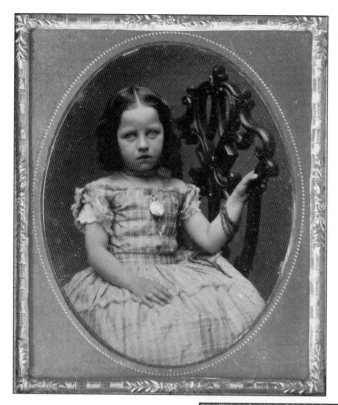

Ellen Rosetta (Coleman) Brown, c. 1857. Ellen Coleman (1852–1935) was born to parents John Coleman and Ellen Betteridge Coleman in New York. Her mother died in childbirth, and her father married his wife's sister, Ann Betteridge Coleman. Unfortunately, she died just a few years later in 1863. John and little Ellen Coleman moved to Massillon to be with family, including his sister Mary and brother Joseph Coleman, the jeweler. Ellen Coleman married Horace C. Brown in 1872. (MM, gift of Miss Annie Thomas, BC 1649.1.)

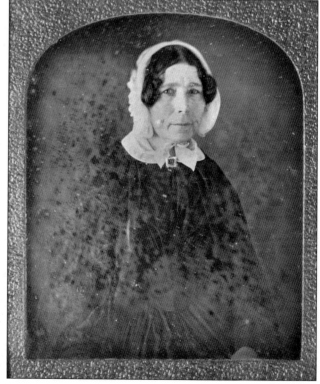

Unidentified Woman, Brown Family, c. 1855. When portrait subjects sat, they often wore their best outfit. Photography was in its infancy and expensive. Some people purchased only one photograph of themselves during their entire lifetime. This lady likely wore her head cover for religious reasons. Her outfit is reserved and simple. (MM, gift of Miss Mary H. Merrick, 67.42.16.)

Mollie Coleman and Child, c. 1855. All members of the Coleman family had their portraits taken when they were in their childhood and adult years. Mollie Bender Coleman, wife of Joseph, poses with her baby, likely Herbert Bailey Coleman, born in 1854. The couple had three children: Albert, Herbert, and Annie Coleman Bahney. (Daguerreotype attributed to Abel Fletcher, MM, gift of Miss Annie Thomas, BC 1633.4.)

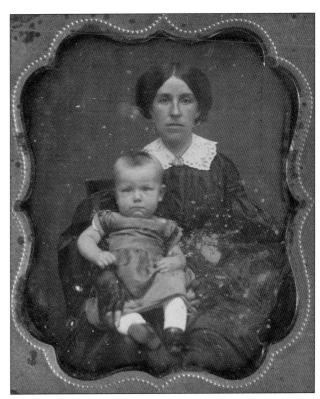

Charlotte Stelling Sewing a Fitted Top, c. 1860. Penciled in on the front of this photograph are the words "Our Boss." Department stores were not commonplace in early Massillon. Pioneer families made their own clothes and repairs. Cottage industries like sewing and laundry were conducted by ladies in homes and, eventually, in larger business establishments. (Photograph by Martha Fletcher, MM, gift of Misses Edna and Bess Spuhler, 58.130.3.)

CHILDREN ON A WAGON, C. 1890. In the early 1800s, there were no laws prohibiting child labor. Massillon children worked with their families on farms and in dry goods stores. These children, possibly delivery boys or shop assistants, posed with barrels on their way to market. (MM, gift of Julia Crookston, Ruth and Fred D. Keen, 86.32.602)

ONE-HORSE PRIVATE CARRIAGE, 1898. Early travel in pioneer country was rough, due to undefined roads. Some travelers and residents had their own horses to ride, and some were lucky enough to own personal carriages, carts, or wagons. Hitching posts were installed throughout Massillon, like the one seen here. (MM, gift of Dan Douglass, 90.25.730)

Plat of West Massillon, May 10, 1831. William Henry Jr. (1777–1857) was born in County Down, Ireland. He embodied the American Dream, arriving a poor immigrant, working his way up in the world, and becoming a businessman and respected judge. He came to America as a young boy. At age 18, Henry became a surveyor for the US government, recording Ohio's State Road between Canton and Mansfield. Later, he surveyed the land next to Indian territory, delineated by the Tuscarawas River. Upon completion, the government gave the surveyors parcels of land, which Henry accepted and added to by purchase. Henry and his fellow surveyors, Joseph Larwell and John Bever, founded Wooster, Ohio, in 1808. In 1810, he settled just west of the Tuscarawas River, newly purchased by the United States. Henry first built a log cabin at the corner of Summit and Plum Streets West, near the Tuscarawas River. His second home was on the west bank of the Tuscarawas at the northeast corner of Cherry Road West and Summit Street. Henry competed and lost to nearby villages of Kendal and Massillon for a post office and the Ohio and Erie Canal, respectively. (MM, museum purchase, 66.77.)

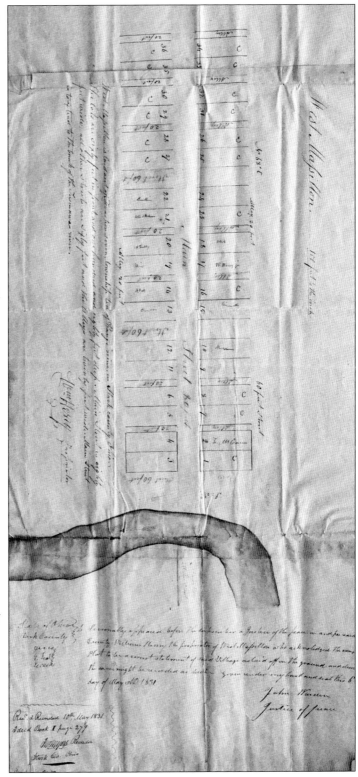

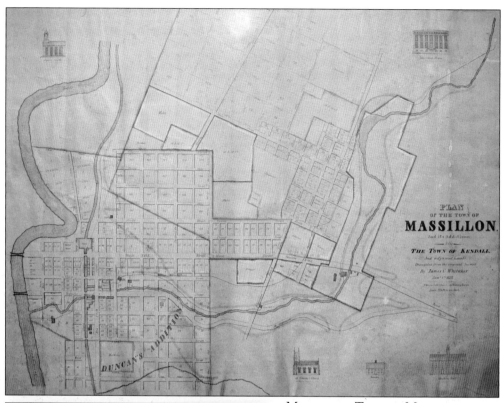

MAP OF THE TOWN OF MASSILLON AND ITS ADDITION, AND KENDAL, 1837. This is the first map showing both Massillon and Kendal. Sketches of important buildings of the time are featured around the map. The original course of the Sippo Creek before the 1886 reservoir can be seen in the northeast section. (SHHH.)

SAMUEL PEASE (1802–1869), FIRST MAYOR OF MASSILLON, C. 1853. Pease came to Massillon in 1831 and established the first successful law practice in town. Elected as the first mayor on May 28, 1853, he served until 1855, and again in 1863. Robert Folger had served for many years as justice of the peace before the town was incorporated. Trustees for the town were Hiram Wellman, Thomas McCullough, Isaac H. Brown, Valentine S. Buckius, Warren G. Richards, and recorder G.W. Williams. (MM, gift of Massillon City Hall, 64.82)

MASSILLON FIREMEN WITH 1856 HUNNEMAN COMPANY VIGILANT HAND-PUMPER, 1885. The fire department began as volunteer fire fighters with leather buckets, often filled from the canal or river by a line of men, or bucket brigade. In 1853, the city purchased a rotary hand engine made by the Cataract Fire Pump Company, from Philadelphia, Pennsylvania. On July 4, 1885, Massillon firemen used their old Vigilant hand-pumper for a water stream competition held in Wooster, Ohio. From left to right are Flaxie Miller, Fred Stryker, Harry Bergemier, Christian Baatz, Owen Miller. (MM, 76.12.2.)

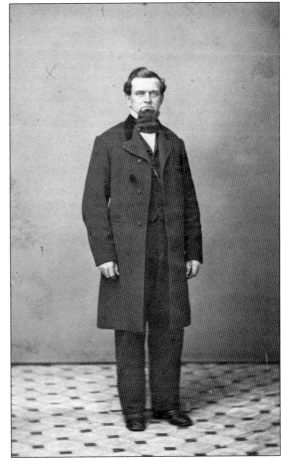

CLEMENT RUSSELL, C. 1860. Russell served as first engine in the city of Massillon's first fire department in 1853. The Massillon Fire Department second engine was James S. Kelley, third engine was Samuel F. Jones, and fourth engine was John D. Hofman. Russell also served as mayor in 1862. (MM, BC 999.1.)

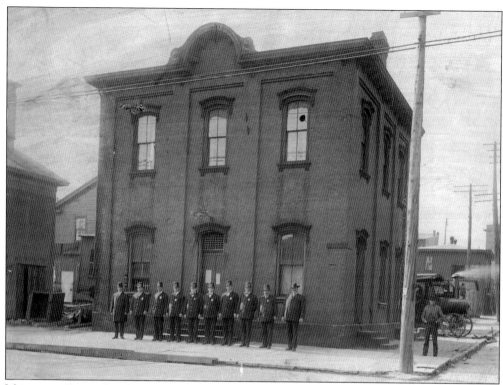

Massillon Police Department, c. 1901. Calvin Hobart was contracted to build the city jail in 1830 for $3,600. This building housed the city council chamber on the second floor, the jail on the first floor, and the police station. The mayor's office was housed in many places in the 1800s, and it is unclear as to whether this was one of the sites. Mayor William Brown was elected in 1856, and Isaac H. Brown served from 1857 to 1860. (MM, gift of Bob and Joanne Miller, 2014.025.1.)

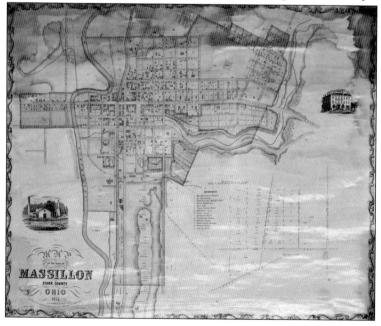

Map of the Town of Massillon, 1854. This map provides the first view of the incorporated city of Massillon that includes Kendal and West Massillon. All three individual towns were connected through various additions. The largest land purchases were made by James Duncan, Charles K. Skinner, and Arvine C. Wales. (MM, gift of Mrs. Horatio Wales.)

Bibliography

Blue, Herbert T.O. *History of Stark County, Ohio: From the Age of Prehistoric Man to the Present Day*. Chicago: S.J. Clark Publishing Company, 1928.
Conrad, Ethel. *A Heritage to Keep: The Story of St. Timothy's Episcopal Church 1836–1986*. Massillon, OH: Self-published, 1986.
———. *Invaluable Friends: Thomas and Charity Rotch*. Self-published. 1991.
Fay, Mary Jarvis. Memoir. Unpublished, Massillon Museum archives, 1896.
Hazimihalis, Katina, Andrew Preston, and Jean Baptiste Massillon. Eds. Lisa Allen, Shane Jackson, JoAnn Shade, and Margy Vogt. *Massillon Connection: A Pioneer Woman, a French Bishop, and a Village on a River*. Massillon, OH: MassMu Press, 2014.
Heald, Edward Thornton. *The Stark County Story, Volumes I–IV*. Stark County Historical Society, 1949.
Howe, Henry. *Historical Collections of Ohio*. Cincinnati: Derby, Bradley, and Company, 1848.
Massillon maps, www.massillonmuseum.org/earlymassillonmaps, accessed 2017.
Perrin, William Henry. *History of Stark County, Volumes I–II*. Chicago: Baskin and Battey, 1881.
Rotch-Wales papers, massillonmemory.org, accessed 2017.
Richeimer, Mary Jane. *A Century of Education*. Massillon, OH: The Stark County Historical Society, 1947.
Siebert, Dr. Wilburt. *Mysteries of Ohio's Underground Railroad*, 1898, page 236.
Skinner, Bessie. *Once Upon a Time in Massillon*. Self-published, 1928.
Smith, Mrs. Barton E. (Georgia). *Upon These Hills: Massillon's Beginnings and Early Days*. Massillon, OH: Daughters of the American Revolution, 1962.
Vogt, Margy. *Massillon: Reflections of a Community*. Massillon, OH: Bates Printing, 2009.
———. *Towpath to Towpath: A History of Massillon, Ohio*. Massillon, OH: Bates Printing, 2002.
Wales, Arvine C. Diary. Unpublished, Massillon Museum archives, 1847–1848.
Wittman, Barbara K. *Thomas and Charity Rotch: The Quaker Experience of Settlement in Ohio in the Early Republic 1800-1824*. United Kingdom: Cambridge Scholars Publishing, 2015.
Woods, Terry K. *The Ohio & Erie Canal in Stark County*. Massillon Museum, 2002.

Discover Thousands of Local History Books Featuring Millions of Vintage Images

Arcadia Publishing, the leading local history publisher in the United States, is committed to making history accessible and meaningful through publishing books that celebrate and preserve the heritage of America's people and places.

Find more books like this at
www.arcadiapublishing.com

Search for your hometown history, your old stomping grounds, and even your favorite sports team.

Consistent with our mission to preserve history on a local level, this book was printed in South Carolina on American-made paper and manufactured entirely in the United States. Products carrying the accredited Forest Stewardship Council (FSC) label are printed on 100 percent FSC-certified paper.